THE VISION MACHINE

THE VISION MACHINE

Paul Virilio

TRANSLATED BY JULIE ROSE

INDIANA UNIVERSITY PRESS
Bloomington and Indianapolis

BFI PUBLISHING

First published in 1994 by the
British Film Institute
21 Stephen Street, London W1P 1PL
and the
Indiana University Press
601 North Morton Street, Bloomington, Indiana 47404

Reprinted 1995, 1996

The British Film Institute exists to encourage the development of film, television and video
in the United Kingdom, and to promote knowledge, understanding and enjoyment of the
culture of the moving image. Its activities include the National Film and Television
Archive; the National Film Theatre; the Museum of the Moving Image; the London Film
Festival; the production and distribution of film and video; funding and support for
regional activities; Library and Information Services; Stills, Posters and Design; Research,
Publishing and Education; and the monthly *Sight and Sound* magazine.

British Library Cataloguing in Publication Data
A catalogue record for this book is available from the British Library.
ISBN 0–85170–444–1
 0–85170–445–X pbk

US Cataloging data available from the Library of Congress

Typeset by
Fakenham Photosetting Ltd, Fakenham, Norfolk

Printed in Great Britain by
St Edmundsbury Press Ltd, Bury St Edmunds, Suffolk

*Memory content is a
function of the rate of
forgetting*

Norman E. Spear

Contents

Chapter 1

A Topographical Amnesia

'The arts require witnesses,' Marmontel once said. A century later Auguste Rodin asserted that it is the visible world that demands to be revealed by means other than the latent images of the phototype.

In the course of his famous conversations with the sculptor, Paul Gsell remarked, apropos Rodin's 'The Age of Bronze' and 'St John the Baptist',[1] 'I am still left wondering how those great lumps of bronze or stone actually seem to move, how obviously immobile figures appear to act and even to be making pretty strenuous efforts. ...'

Rodin retorts, 'Have you ever looked closely at instantaneous photographs of men in motion? ... Well then, what have you noticed?'

'That they never seem to be making headway. Generally, they seem to be standing still on one leg, or hopping.'

'Exactly! Take my "St John", for example. I've shown him with both feet on the ground, whereas an instantaneous photograph taken of a model performing the same movement would most likely show the back foot already raised and moving forward. Or else the reverse – the front foot would not yet be on the ground if the back leg in the photograph were in the same position as in my statue. That is precisely why the model in the photograph would have the bizarre look of a man suddenly *struck with paralysis*. Which confirms what I was just saying about movement in art. People in photographs suddenly seem frozen in mid-air, despite being caught in full swing: this is because every part of their body is reproduced at exactly the same twentieth or fortieth of a second, so there is no gradual unfolding of a gesture, as there is in art.'

Gsell objects, 'So, when art interprets movement and finds itself completely at loggerheads with photography, which is an *unimpeachable mechanical witness*, art obviously distorts the truth.'

'No', Rodin replies, 'It is art that tells the truth and photography that lies. For *in reality time does not stand still*, and if the artist manages to give the impression that a gesture is being executed over several seconds, their work is certainly much less conventional than the scientific image in which time is abruptly suspended. ...'

Rodin then goes on to discuss Géricault's horses, going flat out in the painting 'Race at Epsom', and the critics who claim that the photographic plate never gives the same impression. Rodin counters that the artist condenses several successive movements into a single image, so *if the representation as a whole is false in showing these movements as simultaneous, it is true when the parts are observed in sequence, and it is only this truth that counts since it is what we see and what impresses us.*

Prompted by the artist to follow the progress of a character's action, the spectator, scanning it, has the illusion of seeing the movement performed. This illusion is thus not produced *mechanically* as it would later be with the snapshots of the chronophotographic apparatus, through retinal retention – photosensivity to light stimuli – but *naturally*, through eye movement.

The *veracity* of the work therefore depends, in part, on this solicitation of eye (and possibly body) movement in the witness who, in order to *sense* an object with maximum clarity, must accomplish an enormous number of tiny, rapid movements from one part of the object to another. Conversely, if the eye's motility is transformed into fixity '*by artificial lenses or bad habits*, the sensory apparatus undergoes distortion and vision degenerates. ... In his greedy anxiety to achieve his end, which is to do the greatest possible amount of good seeing in the shortest possible time, the starer neglects the only means whereby this end can be achieved.'[2]

Besides, Rodin insists, the *veracity* of the whole is only made possible through the lack of precision of details conceived merely as so many material props enabling either a falling short of or a going beyond immediate vision. The work of art requires witnesses because it sallies forth with its image into the depths of a material time which is also our own. This sharing of duration is automatically defeated by the innovation of photographic instantaneity, for if the instantaneous image pretends to scientific accuracy in its details, the snapshot's image-freeze or rather *image-time-freeze* invariably distorts the witness's felt temporality, *that time that is the movement of something created.*[3]

The plaster studies on show in Rodin's atelier at Meudon reveal a state of evident anatomical breakdown – huge, unruly hands and feet, dislocated, distended limbs, bodies in suspension – the representation of movement pushed to the limits of collapse or take-off. From here it is only a step to Clément Ader and the first aeroplane flight, the conquest of the air through mobilisation of something heavier than

air which is followed, in 1895, by cinematography's mobilisation of the snapshot, *retinal take-off*, that moment when, with the achievement of metabolic speeds, '*all that we called art seems to have become paralytic*, while the film-maker lights up the thousand candles of his projectors'.[4]

When Bergson asserts that *mind is a thing that endures*, one might add that it is our duration that thinks, feels, sees. The first creation of consciousness would then be its own speed in its time-distance, speed thereby becoming causal idea, idea before the idea.[5] It is thus now common to think of our memories as multidimensional, of thought as transfer, transport (*metaphora*) in the literal sense.

Already Cicero and the ancient memory-theorists believed you could consolidate natural memory with the right training. They invented a *topographical system*, the Method of Loci, an imagery-mnemonics which consisted of selecting a sequence of places, locations, that could easily be ordered in time and space. For example, you might imagine wandering through the house, choosing as loci various tables, a chair seen through a doorway, a windowsill, a mark on a wall. Next, the material to be remembered is coded into discreet images and each of the images is inserted in the appropriate order into the various loci. To memorise a speech, you transform the main points into concrete images and mentally 'place' each of the points in order at each successive locus. When it is time to deliver the speech, all you have to do is recall the parts of the house in order.

The same kind of training is still used today by stage actors and barristers at court. It was members of the theatre industry like *Kammerspiel* theorists Lupu Pick and the scenarist Carl Mayer who, at the beginning of the 1920s, took the whole thing to ludicrous lengths as a film technique, offering the audience a kind of cinematic *huis clos* occurring in a unique place and at the exact moment of projection. Their film sets were not expressionist but realist so that familiar objects, the minutiae of daily life, assume an obsessive symbolic importance. According to its creators, this was supposed to render all dialogue, all subtitles superfluous.

The silent screen was to make the surroundings speak the same way practitioners of *artificial memory* made the room they lived in, the theatre boards they trod speak, *in retrospect*. Following Dreyer and a host of others, Alfred Hitchcock employed a somewhat similar coding system, bearing in mind that viewers do not manufacture mental images on the basis of what they are immediately given to see, but on the basis of their memories, *by themselves filling in the blanks and their minds with images created retrospectively, as in childhood*.

For a traumatised population, in the aftermath of the First World War, the *Kammerspiel* cinema altered the conditions of invention of

artificial memory, which was itself also born of the catastrophic disappearance of the scenery. The story goes that the lyrical poet Simonides of Chios, in the middle of reciting a poem at a banquet, was suddenly called away to another part of the house. As soon as he left the room, the roof caved in on the other guests and, as it was a particularly heavy roof, they were all crushed to a pulp.

But with his sharpened memory, Simonides could recall the exact place occupied by each of the unfortunate guests and the bodies could thus be identified. It then really dawned on Simonides what an advantage this method of picking places and filling them in with images could be in practising the art of poetry.[6]

In May 1646 Descartes wrote to Elizabeth, 'There is such a strong connection between body and soul that thoughts that accompanied certain movements of our body at the beginning of our lives, go on accompanying them later.' Elsewhere he tells how he once as a child loved a little girl with a slight squint, and how *the impression his brain received through sight whenever he looked at her wandering eyes* remained so vividly present that he continued to be drawn to people with the same defect for the rest of his life.

The moment they appeared on the scene, the first optical devices (Al-Hasan ibn al-Haitam aka Alhazen's camera obscura in the tenth century, Roger Bacon's instruments in the thirteenth, the increasing number of visual prostheses, lenses, astronomic telescopes and so on from the Renaissance on) profoundly altered the contexts in which mental images were topographically stored and retrieved, the *imperative to re-present oneself*, the imaging of the imagination which was such a great help in mathematics according to Descartes and which he considered a veritable part of the body, *veram partem corporis*.[7] Just when we were apparently procuring the means to see further and better the unseen of the universe, we were about to lose what little power had of imagining it. The telescope, that epitome of the visual prosthesis, projected an image of a world beyond our reach and thus another way of moving about in the world, the *logistics of perception* inaugurating an unknown conveyance of sight that produced a telescoping of near and far, a *phenomenon of acceleration* obliterating our experience of distances and dimensions.[8]

More than a return to Antiquity, the Renaissance appears today as the advent of a period when all intervals were cleared, a sort of morphological 'breaking and entering' that immediately impacted on the reality-effect: once astronomic and chronometric apparatuses went commercial, geographical perception became dependent on anamorphic processes. Painters such as Holbein, who were contemporaries of Copernicus, practised a kind of iconography in which technology's first stab at leading the senses astray occupied centre

stage thanks to singularly mechanistic optical devices. Apart from the displacement of the observer's point of view, complete perception of the painted work could only happen with the aid of instruments such as glass cylinders and tubes, the play of conical or spherical mirrors, magnifying glasses and other kinds of lenses. The reality-effect had become a dissociated system, a puzzle the observer was unable to solve without some traffic in light or the appropriate prostheses. Jurgis Baltrusaïtis reports that the Jesuits of Beijing used anamorphic equipment as instruments of religious propaganda to impress the Chinese and to demonstrate to them 'mechanically' that man should experience the world as an illusion of the world.[9]

In a celebrated passage of *I Saggiatore* (1623), Galileo exposes the essential features of his method: 'Philosophy is written in the immense Book of Nature which is constantly before our very eyes and which cannot be (humanly) understood unless one has previously learned the language and alphabet in which it is written. It is written in mathematical characters....'

We imagine it (mathematically) because it remains continually before our very eyes from the moment we first see the light of day. If, in this parabola, the duration of the visible seems simply to persist, geomorphology has disappeared or is at least reduced to an abstract language plotted on one of the first great industrial media (with all the artillery so vital to the disclosure of optical phenomena).

The celebrated Gutenberg Bible had by then been in print for nearly two centuries and the book trade in Europe, with a printing works in every town and a great number of them in the capitals, had already disseminated its products in the millions. Significantly, the 'art of writing artificially' as it was then called, was also, from its inception, placed at the service of religious propaganda, the Catholic Church at first, then the Reformation. But it was also an instrument of diplomatic and military propaganda, a fact that would later earn it the name *thought artillery*, well before Marcel L'Herbier labelled his camera a *rotary image press*.

A connoisseur of optical mirages, Galileo now no longer preferred to form images in the world directly in order to imagine it; he took up instead the much more limited oculomotor labour of reading.[10]

From Antiquity, a progressive simplification of written characters can be discerned, followed by a simplification of typographical composition which corresponded to an acceleration in the transmission of messages and led logically to the radical abbreviation of the contents of information. The tendency to make reading time as intensive as speaking time stemmed from the tactical necessities of military conquest and more particularly of the battlefield, that occasional field of

perception, privileged space of the vision of the trooper, of rapid stimuli, slogans and other logotypes of war.

The battlefield is the place where social intercourse breaks off, where political rapprochement fails, making way for the inculcation of terror. The panoply of acts of war thus always tends to be organised at a distance, or rather, to organise distances. Orders, in fact speech of any kind, are transmitted by long-range instruments which, in any case, are often inaudible among combatants' screams, the clash of arms, and, later, the various explosions and detonations.

Signal flags, multicoloured pennants, schematic emblems then replace faltering vocal signals and constitute a *delocalised language* which can now be grasped via brief and distant glances, inaugurating a vectorisation that will become concrete in 1794 with the first aerial telegraph line between Paris and Lille and the announcement, at the Convention, of the French troops' victory at Condé-sur-l'Escaut. That same year, Lazare Carnot, organiser of the Revolution's armies, recorded the speed of transmission of military information that was at the very heart of the nation's political and social structures. He commented that if terror was the order of the day, it could thereafter hold sway at the front just as well and at the same time as behind the lines.

Some time later, at the moment when photography became instantaneous, messages and words, reduced to a few elementary signs, were themselves telescoped to the speed of light. On 6 January 1838 Samuel Morse, the American physicist and painter of battle-scenes, succeeded in sending the first electric-telegraph message from his workshop in New Jersey. (The term meaning *to write at a distance* was also used at the time to denote certain stagecoaches and other means of fast transport.)

The race between the *transtextual* and the *transvisual* ran on until the emergence of the *instantaneous ubiquity* of the audiovisual mix. Simultaneously tele-diction and television, this ultimate transfer finally undermines the age-old problematic of the *site where mental images are formed* as well as that of the consolidation of natural memory.

'The boundaries between things are disappearing, the subject and the world are no longer separate, time seems to stand still', wrote the physicist Ernst Mach, known particularly for having established the role of the speed of sound in aerodynamics. In fact the *teletopological* phenomenon remains heavily marked by its remote beginnings in war, and does not *bring the subject closer* to the world. ... In the manner of the combatant of antiquity, it anticipates human movement, outstripping every displacement of the body and abolishing space.

With the industrial proliferation of visual and audiovisual prostheses and unrestrained use of instantaneous-transmission equipment

from earliest childhood onwards, we now routinely see the encoding of increasingly elaborate mental images together with a steady decline in retention rates and recall. In other words we are looking at the rapid collapse of mnemonic consolidation.

This collapse seems only natural, if one remembers *a contrario* that seeing, and its spatio-temporal organisation, precede gesture and speech and their co-ordination in knowing, recognising, making known (as images of our thoughts), our thoughts themselves and cognitive functions, which are never ever passive.[11]

Communicational experiments with newborn babies are particularly instructive. A small mammal condemned, unlike other mammals, to prolonged semi-immobility, the child, it seems, hangs on maternal smells (breast, neck ...), but also on eye movements. In the course of an eye-tracking exercise that consists of holding a child of about three months in one's arms, at eye level and face to face, and turning it gently from right to left, then from left to right, the child's eyes 'bulge' in the reverse direction, as makers of old porcelain dolls clearly saw, simply because the infant does not want to lose sight of the smiling face of the person holding it. The child experiences this exercise in the expansion of its field of vision as deeply gratifying; it laughs and wants to go on doing it. Something very fundamental is clearly going on here, since the infant is in the process of forming a lasting communicational image by mobilising its eyes. As Lacan said, *communication makes you laugh* and so the child is in an ideally human position.

Everything I see is in principle within my reach, at least within reach of my sight, marked on the map of the 'I can'. In this important formulation, Merleau-Ponty pinpoints precisely what will eventually find itself ruined by the banalisation of a certain teletopology. The bulk of what I see is, in fact and in principle, no longer within my reach. And even if it lies within reach of my sight, it is no longer necessarily inscribed on the map of the 'I can'. The logistics of perception in fact destroy what earlier modes of representation preserved of this original, ideally human happiness, the 'I can' of sight, which kept art from being obscene. I have often been able to confirm this watching models who were perfectly happy to pose in the nude and submit to whatever painters and sculptors wanted them to do, but flatly refused to allow themselves to be photographed, feeling that that would amount to a pornographic act.

There is a vast iconography evoking this prime communicational image. It has been one of the major themes in Christian art, presenting the person of Mary (named *Mediator*) as the initial map of the Infant-God's '*I can*'. Conversely, the Reformation's rejection of consubstantiality and of such close physical proximity intervenes during the Renaissance, with the proliferation of optical devices. ... Romantic poetry is one of the last movements to employ this type of car-

tography. In Novalis, the body of the beloved (having become profane) is the universe in miniature and the universe is merely the extension of the beloved's body.

So in spite of all this machinery of transfer, we get no closer to the *productive unconscious of sight*, something the surrealists once dreamed of in relation to photography and cinema. Instead, we only get as far as its *unconsciousness*, an annihilation of place and appearance the future amplitude of which is still hard to imagine. *The death of art*, heralded from the beginning of the nineteenth century, turns out to be merely an initial, disquieting symptom of this process, despite being unprecedented in the history of human societies. This is the emergence of the deregulated world that Hermann Rauschning, the author of *The Revolution of Nihilism*, spoke about in November 1939 in relation to Nazism's project: *the universal collapse of all forms of established order, something never before seen in human memory*. In this unprecedented crisis of representation (bearing absolutely no relation to some kind of classic decadence), the age-old *act of seeing* was to be replaced by a regressive perceptual state, a kind of *syncretism*, resembling a pitiful caricature of the semi-immobility of early infancy, the sensitive substratum now existing only as a fuzzy morass from which a few shapes, smells, sounds accidentally leap out ... more sharply perceived.

Thanks to work like that of W. R. Russell and Nathan (1946), scientists have become aware of the relationship of post-perceptual visual processes to time. The storage of mental images is never instantaneous; it has to do with the processing of perception. Yet it is precisely this storage process that is rejected today. The young American film-maker Laurie Anderson, among others, is able to declare herself *a mere voyeur interested only in details*; as for the rest, she says, '*I use computers that are tragically unable to forget, like endless rubbish dumps.*'[12]

Returning to Galileo's simile of deciphering the book of the real, it is not so much a question here of what Benjamin called the *image-illiteracy* of the photographers incapable of reading their own photographs. It is a question of *visual dyslexia*. Teachers have been saying for a long time now that the last few generations have great difficulty understanding what they read because they are incapable of *re-presenting* it to themselves. ... For them, words have in the end lost their ability to come alive, since images, more rapidly perceived, were supposed to replace words according to the photographers, the silent film-makers, the propagandists and advertisers of the early twentieth century. Now there is no longer anything to replace, and the number of the visually illiterate and dyslexic keeps mutliplying.

Here again, recent studies of dyslexia have established a direct connection between the subject's visual abilities, on the one hand, and language and reading on the other. They frequently record a weaken-

ing of central (foveal) vision, the site of the most acute sensation, along with subsequent enhancing of a more or less frantic peripheral vision – a dissociation of sight in which the heterogeneous swamps the homogeneous. This means that, as in narcotic states, the series of visual impressions become meaningless. They no longer seem to belong to us, they just exist, as though the speed of light had won out, this time, over the totality of the message.

If we think about light, which has no image and yet creates images, we find that the use of light stimuli in crowd control goes back a long way.

The inhabitant of the ancient city, for instance, was not the indoors type; he was out on the street, except at nightfall for obvious safety reasons. Commerce, craft, riots and daily brawls, traffic jams. ... Bossuet was worried about this chronic lightweight who could not keep still, did not stop to think where he was going, who no longer even knew where he was and would soon be mistaking night for day. At the end of the seventeenth century, police lieutenant La Reynie came up with 'Lighting Inspectors' to reassure the Parisian public and encourage them to go out at night. When he quit his post in 1697, having been promoted chief of police, there were 6,500 lanterns lighting up the capital which would soon be known by contemporaries as the *city of light* for 'the streets are ablaze all through winter and even of a full moon', as the Englishman Lister wrote, comparing Paris to London which enjoyed no such privilege.

In the 18th century the by now rather shady population of Paris mushroomed and the capital became known as the *New Babylon*. The brightness of its lighting signalled not just a desire for security, but also individual and institutional economic prosperity, as well as the fact that 'brilliance is all the rage' among the new elites – bankers, gentlemen farmers and the nouveaux riches of dubious origins and careers. Whence the taste for garish lights which no lampshade could soften. On the contrary, they were amplified by the play of mirrors multiplying them to infinity. Mirrors turned into dazzling reflectors. *A giorno* lighting now spilled out of the buildings where it once helped turn reality into illusion – theatres, palaces, luxury hotels, princely gardens. Artificial light was in itself a spectacle soon to be made available to all, and street lighting, the democratisation of lighting, is designed to trick everyone's eyes. There is everything from old-fashioned fireworks to the light shows of the engineer Philippe Lebon, the inventor of the gaslight who, in the middle of a social revolution, opened the Seignelay Hotel to the public so they might appreciate the value of his discovery. The streets were packed at night with people gazing upon the works of lighting engineers and pyro-technists known collectively as *impressionists*.[13]

But this constant straining after 'more light' was already leading to a sort of precocious disability, a blindness; the eye literally popped

out of its socket. In this respect the delegation of sight to Nièpce's *artificial retinas*, took on its full meaning.[14] Faced with such a permanent regime of bedazzlement, the range of adaptability of the eye's crystalline lens was quickly lost. Madame de Genlis, then governess to the children of Louis-Philippe, pointed to the damage caused by the abuse of lighting: 'Since lamps have come into fashion, it is the young who are wearing glasses; good eyes are now only to be found among the old who have kept up the habit of reading and writing with a candle shaded by a candle guard.'

That perverted peasant and Paris pedestrian, Restif de la Bretonne, observing life with the rustic's sharp eye, soon gave way to a new, anonymous, ageless character who no longer took to the streets looking for *a man*, like Diogenes with his lantern burning in broad daylight. He now sought light itself, for where there is light there is the crowd. According to Edgar Allan Poe, our man no longer inhabited the big city strictly speaking (London, as it happens), but the dense throng. His only itinerary was that of the human stream wherever it was bound, wherever it was to be found. *All was dark yet splendid*, Poe wrote, and the man's only terror was the risk of losing the crowd thanks to the strange light effects, to the speed with which the world of light vanishes. ...' For this man, frowning furiously, shooting frantic looks here, there and everywhere towards all those swarming round him, drowning in the flood of images, one face constantly being gobbled up by another, the endless surging throng permitted only the briefest glance at any one face. When, having pursued him for hours, the exhausted author finally caught up and planted himself right in front of him, the man was pulled up short for a second, but looked straight through the author without even seeing him, then immediately flitted off on his merry manic way.[15]

In 1902 it was Jack London's turn to come to London and he too followed, step by step, the *people of the abyss*. Urban lighting had by then become a torture for the mass of social rejects of the capital of the world's most powerful Empire. The vast mob of the homeless represented more than 10 per cent of London's population of six million. They were not allowed to sleep at night anywhere, whether in parks, on benches or on the street; they had to keep walking till dawn, when they were finally allowed to lie down in places where there was little danger of anyone seeing them.[16]

No doubt because contemporary architects and townplanners have no more than anyone else been able to escape such psychotropic disorders (the topographical amnesia described by neuropathologists as the *Elpenor Syndrome* or *incomplete awakening*[17]), one can say, with Agnès Varda, that *the most distinctive cities bear within them the capacity of being nowhere* ... the dream décor of oblivion.

So, in Vienna, in 1908, Adolf Loos delivered his celebrated discourse *Ornament and Crime*, a manifesto in which he preaches the

standardisation of *total functionalism* and waxes lyrical about the fact that 'the greatness of our age lies in its inability to produce a new form of decoration'. For, he claims, 'in fashioning ornaments human labour, money and material are ruined'. Loos considered this a real crime 'which we cannot simply shrug off'. This would be followed by Walter Gropius' 'industrial-building production standards', the ephemeral architecture of the Italian Futurist Fortunato Depero, the Berlin *Licht-Burg*, Moholy-Nagy's *space-light modulators*, Kurt Schwerdtfeger's *reflektorische Farblichtspiel* of 1922. ...

In fact, the constructivist aesthetic would forever continue to hide behind the banalisation of form, the transparency of glass, the fluidity of vectors and the special effects of machines of transfer or transmission. When the Nazis came to power, busily persecuting 'degenerate artists' and architects and extolling the stability of materials and the durability of monuments, their resistance to time and to the obliviousness of history, they were actually putting the new psychotropic power to good use for propaganda purposes.

Hitler's architect, Albert Speer, organised the Nazi Zeppelin Field festivities and advocated the value of ruins. For the party rally at Nuremberg in 1935, he used 150 anti-aircraft searchlights with their beams pointing upwards, making a rectangle of light in the night sky. ... He wrote: 'Within these luminous walls, the first of their kind, the rally took place with all its rituals. ... I now feel strangely moved by the idea that the most successful architectural creation of my life was a chimera, an immaterial mirage.'[18] Doomed to disappear at first light, leaving no more material trace than a few films and the odd photograph, the 'crystal castle' was especially aimed at Nazi militants who, according to Goebbels, *obey a law they are not even consciously aware of but which they could recite in their dreams.*

On the basis of 'scientific' analysis of the stenographic speed of his various speeches, Hitler's master of propaganda had invented, again in his own estimation, a *new mass language* which 'no longer has anything to do with archaic and allegedly popular forms of expression'. He added: 'This is the beginning of an *original aesthetic style*, a vivid and galvanising form of expression.'

At least he was good at self-promotion. Such declarations recall those of Futurists such as the Portuguese Mario de Sá-Carneiro (d.1916) celebrating *The Assumption of the Acoustic Waves*:

'Aaagh! Aaagh!/ The vibrating mass is pressing in. ... I can even feel myself being carried along by the air, like a ball of wool!'

Or Marinetti who, as a war correspondent in Libya, was inspired by wireless telegraphy and all the other techniques of topographical amnesia besides – explosives, projectiles, planes, fast vehicles – to compose his poems.

The Futurist movements of Europe did not last. They disappeared in a few short years, nudged along by a bit of repression. In Italy they

were responsible for anarchist and fascist movements – Marinetti was a personal friend of Il Duce – but all were quickly swept from the political stage.

No doubt they had come a little too close to the bone in exposing the conjunction between communication technologies and the totalitarianism that was then taking shape before 'Newly annointed eyes – Futurist, Cubist, intersectionist eyes, which never cease to quiver, to absorb, to radiate all that spectral, transferred, substitute beauty, all that unsupported beauty, dislocated, standing out. ...'[19]

With *topographical memory*, one could speak of *generations of vision* and even of visual heredity from one generation to the next. The advent of the logistics of perception and its renewed vectors for delocalising geometrical optics, on the contrary, ushered in a eugenics of sight, a pre-emptive abortion of the diversity of mental images, of the swarm of image-beings doomed to remain unborn, no longer to see the light of day anywhere.

This problematic was beyond scientists and researchers for a long time. The work of the Vienna School, such as that of Riegl and Wickhoff, addressed the implied relations between modes of perception and the periods when they were on the agenda. But for the most part research remained limited to the investigation, de rigeur at the time, of the socio-economics of the image. Throughout the nineteenth century and for the first half of the twentieth, studies of human-memory processes were also largely functionalist, inspired in the main by the various learning processes and the conditioning of animals; here too, electrical stimuli played a part. The military supported such research and so, subsequently, did ideologues and politicians keen to obtain immediate practical social spin-offs. In Moscow, in 1920 a Russian committee was set up to promote collaboration between Germany and the Soviet Union in the area of racial biology. Among other things the work of the German neuropathologists sojourning in the Soviet capital was supposed to locate man's 'centre of genius' as well as the centre of mathematical learning. ... The committee came under the authority of Kalinin, who was to be president of the praesidium of the Supreme Soviet Council from 1937 to 1946.

This was the real beginning, technically and scientifically speaking, of power based on hitherto unrecognised forms of postural oppression and, once again, the battlefield would ensure rapid deployment of the new physiological prohibitions.

As early as 1916, during the first great mediatised conflict in history, Doctor Gustave Lebon had remarked: 'Old-fashioned psychology considered personality as something clearly defined, barely susceptible to variation. ... This person endowed with a fixed personality now appears to be a figment of the imagination.'[20]

With the relentless churning up of the war's landscapes, he noted

that the personality's alleged fixity had depended to a large extent, till then, on the permanence of the natural environment.

But what kind of permanence did he have in mind, and which environment? Is it the environment Clausewitz refers to, that battlefield where, beyond a certain threshold of danger, reason *thinks of itself differently*? Or, more precisely, is it the environment which is constantly targeted, intercepted by an optical arsenal going from the 'line of sight' of the firearm – cannons, rifles, machine guns, used on an unprecedented scale – to cameras, the high-speed equipment of aerial intelligence, projecting an image of a de-materialising world?

The origin of the word propaganda is well known: *propaganda fide*, propagation of the faith. The year 1914 not only saw the physical deportation of millions of men to the battlefields. With the apocalypse created by the deregulation of perception came a different kind of diaspora, the moment of panic when the mass of Americans and Europeans could no longer believe their eyes, when their *faith in perception* became slave to the faith in the technical *sightline* [line of faith]: in other words, the visual field was reduced to the line of a sighting device.[21]

A little later the director Jacques Tourneur confirmed the truth of this: 'In Hollywood I soon learned that the camera never sees everything. I could see everything, but the camera only sees sections.'

But what does one see when one's eyes, depending on sighting instruments, are reduced to a state of rigid and practically invariable structural immobility? One can only see instantaneous sections seized by the Cyclops eye of the lens. *Vision, once substantial, becomes accidental.* Despite the elaborate debate surrounding the problem of the objectivity of mental or instrumental images, this revolutionary change in the regime of vision was not clearly perceived and the fusion-confusion of eye and camera lens, the passage from vision to visualisation, settled easily into accepted norms. While the human gaze became more and more fixed, losing some of its natural speed and sensitivity, photographic shots, on the contrary, became even faster. Today professional and amateur photographers alike are mostly happy to *fire off shot after shot*, trusting to the power of speed and the large number of shots taken. They rely slavishly on the contact sheet, preferring to observe their own photographs to observing some kind of reality. Jacques-Henri Lartigue, who called his camera his *memory's eye*, abandoned focusing altogether, knowing without looking what his Leica would see, even when holding it at arm's length, the camera becoming a substitute for both eye and body movements at once.

The reduction in mnesic choices which ensued from this dependence on the lens was to become the nodule in which the modelling of vision would develop and, with it, all possible standardisations of ways of seeing. Thanks to work on animal conditioning like that of

13

Thorndike (1931) and McGeoch (1932), a new certainty was born. To retrieve a specific target attribute, it was no longer necessary to activate a whole array of attributes, *any single one of them being able to act independently*. This fact once again begged the frequently asked question of *the trans-situational identity of mental images*.[22]

From the beginning of the century the perceptual field in Europe was invaded by certain signs, representations and logotypes that were to proliferate over the next twenty, thirty, sixty years, outside any immediate explanatory context, like beak-nosed carp in the polluted ponds they depopulate. Geometric brand-images, initials, Hitler's swastika, Charlie Chaplin's silhouette, Magritte's blue bird or the red lips of Marilyn Monroe: parasitic persistence cannot be explained merely in terms of the power of technical reproducibility, so often discussed since the nineteenth century. We are in effect looking at the logical outcome of a system of message-intensification which has, for several centuries, assigned a primordial role to the techniques of visual and oral communication.

On a more practical note, Ray Bradbury recently remarked: 'Film-makers *bombard with images* instead of words and accentuate the details using special effects. ... You can get people to swallow anything by intensifying the details.'[23]

The phatic image – a targeted image that forces you to look and holds your attention – is not only a pure product of photographic and cinematic focusing. More importantly it is the result of an ever-brighter illumination, of the intensity of its definition, singling out only specific areas, the context mostly disappearing into a blur.

During the first half of the twentieth century this kind of image immediately spread like wildfire in the service of political or financial totalitarian powers in acculturated countries, like North America, as well as in destructured countries like the Soviet Union and Germany, which were carved up after revolution and military defeat. In other words, in nations morally and intellectually in a state of least resistance. There the key words of poster ads and other kinds of posters would often be printed on a background in just as strong a colour. The difference between what was in focus and its context, or between image and text, was nevertheless stressed here as well, since the viewer had to spend more time trying to decipher the written message or simply give up and just take in the image.

Since the fifth century, Gérard Simon notes, the geometrical study of sight formed part of the pictorial techniques artists were bent on codifying. Thanks to the celebrated passage in Vitruvius, we also know that from Antiquity artists were at pains to give the illusion of depth, particularly in theatre sets.[24]

But in the Middle Ages *the background came to the surface* in

14

pictorial representation. All the characters, even the most minute details – the context, if you like – remain on the same plane of legibility, of visibility. Only their exaggerated size, the way they loom forward suggesting pride of place, draws the observer's attention to certain important personages. Here everything is seen in the same light, in a transparent atmosphere, a brightness further highlighted by golds and halos, by ornaments. These are holy pictures, establishing a theological parallel between vision and knowledge, for which there are no blurred areas.

The latter make their first appearance with the Renaissance when religious and cosmogonical uncertainties begin to proliferate along with the proliferation of optical devices. Once you have smoke effects or distant mists, it is just a short step to the notion of the *non finito*, the unfinished vision of pictorial representation or statuary. In the eighteenth century, with the fashion in geological follies and the curling lines of the rococo and the baroque, architects like Claude Nicolas Ledoux at the Arc-et-Senans saltworks revelled in playing up the contrasts in the chaotic arrangement of matter, with untidy piles of stone blocks escaping the creator's grip on geometry. At the same time monumental ruins, real or fake, were very much in vogue.

Some sixty years later, chaos had taken over the entire structure of the painted work. *The composition decomposes.* The Impressionists deserted their studios and wandered off to catch real life in the act, the way the photographers were doing but with the advantage, soon to be lost, of colour.

With Edgar Degas, painter and amateur photographer, composition came close to framing, to positioning within the range of the viewfinder: the subjects seem decentred, segmented, viewed from above or below in an artificial, often harsh light, like the glare of the reflectors used by professional photographers at the time. 'We must free ourselves from nature's tyranny', Degas wrote of an art which, in his terms, *sums itself up rather than extends itself* . . . , and which also becomes more intense. This goes to show how apt was the nickname given to the new school of painting when Monet's canvas 'Impression Sunrise' was shown: *impressionist*, like the pyrotechnists who created those eye-dazzling displays of flashing, flooding lights.

From the disintegration of composition we move on to that of sight. With pointillism, Georges Seurat reproduced the visual effect of the 'pitting' of the first daguerreotypes as well as applying a system of analogous dots to colour. In order to be restored, the image had to be seen at a certain distance, the observers doing their own focusing, exactly as with an optical apparatus, the dots then dissolving in the effect of luminance and vibrating within emerging figures and forms.

It was not long before these too disintegrated and soon only a visual message worthy of morse code will survive, like Duchamp's retinal stimulator, or aspects of Op Art from Mondrian.

With the same implacable logic, publicity-seekers pop up on the art scene. Futurism is upon us, notably in the form of Depero's promotional architecture, followed by Dada in 1916 and then Surrealism. In Magritte's view, painting and the traditional arts from this moment on lose *any sense of the sacred*. An advertising executive by profession, Magritte wrote:

'What surrealism officially means is an advertising firm run with enough nous and conformism to be able to do as well as other businesses to which it is opposed only in certain details of pure form. Thus, "surrealist woman" was just as stupid an invention as the *pin-up girl* who has now taken her place. ... I'm not much of a surrealist at all, then. To me, the term also signifies "propaganda" (a dirty word) and all the inanity essential to the success of any 'propaganda'.[25]

But the syncretism, the nihilism, of which the techniques of the pseudo-communications company are carriers, are also to be found in Magritte as anxiety-producing symptoms. For Magritte, words are *'slogans that oblige us to think in a certain preordained order ...* contemplation is a banal feeling of no interest'. As for 'the perfect painting', this could only produce an *intense effect* for a very short time. With the industrial multiplication of optical equipment, the artist's human vision is no more than one process among many of obtaining images. The following generation would attack 'the very essence of art', thereby putting the finishing touches to their own suicide.

In 1968 Daniel Buren explained to Georges Boudaille: 'It's funny when you realise that art was never a problem of depth but one of form. ... The only solution lies in the creation – if the word can still be used – of something totally unconnected with what has gone before, completely unburdened by the past. This thing would thereby express itself just for the sake of it. Artistic communication is then cut off, no longer exists. ...'[26]

Well before this, Duchamp wrote: 'I have never stopped painting. Every painting must exist in your mind before it is painted on the canvas and it always loses something in the painting. *I'd rather see my painting without the murk.*'

The painter takes his body with him, Valéry said. Merleau-Ponty added: 'It's hard to see how a Mind could paint'.[27] If art poses the enigma of the body, the enigma of technique poses the enigma of art. In fact devices for seeing dispense with the artist's body in so far as it is light that actually makes the image.

We have all had enough of hearing about the death of God, of man, of art and so on since the nineteenth century. What in fact happened was simply the progressive disintegration of a faith in perception founded in the Middle Ages, after animism, on the basis of the unicity of divine creation, the absolute intimacy between the universe and the

God-man of Augustinian Christianity, a material world which loved itself and contemplated itself in its one God. In the West, the death of God and the death of art are indissociable; *the zero degree of representation* merely fulfilled the prophecy voiced a thousand years earlier by Nicephorus, Patriarch of Constantinople, during the quarrel with the iconoclasts: 'If we remove the image, not only Christ but the whole universe disappears.'

Notes

1. Paul Gsell, *Auguste Rodin. L'Art: Entretiens réunis par Paul Gsell* (Paris: Grasset/Fasquelle, 1911). The quotation from Marmontel is adapted from his *Contes moraux*: 'Music is the only talent that can be enjoyed by itself; all others require witnesses.'
2. Aldous Huxley, *The Art of Seeing* (London: Chatto and Windus, 1943).
3. Pascal, *Réflexions sur la géometrie en général*, vol. Vll no. 33. The studies of Marey and Muybridge fascinated Parisian artists of the period, particularly Kupka and Duchamp whose celebrated canvas 'Nude Descending a Staircase', was rejected in 1912 by the Salon des Indépendants. Already in 1911, when Gsell's interviews with Rodin appeared, Duchamp claimed to show *static compositions using static directions for the various positions taken by a form in motion without trying to create cinematic effects through painting*. If he too claimed that movement is in the eye of the beholder, he hoped to obtain it through *formal decomposition*.
4. Tristan Tzara, 'Le Photographe à l'envers Man Ray' in *Sept Manifestes DADA* (Paris, 1992) – modified.
5. Paul Virilio, *Esthétique de la disparition* (Paris: Balland, 1980).
6. The important work of Norman E. Spear, *The Processing of Memories: Forgetting and Retention* (Hillsdale, NJ: Laurence Erlbaum Associates, 1978).
7. ATX 414. Descartes does not completely spurn the imagination as is too often claimed.
8. Paul Virilio, *L'Espace critique* (Paris: Christian Bourgois, 1984) and *Guerre et cinéma l: Logistique de la perception* (Paris: Editions de l'Etoile Cahiers du cinéma, 1984; London: *War and Cinema*, Verso, 1986).
9. Jean-Louis Ferrier, *Holbein. Les ambassadeurs* (Paris: Denoël, 1977).
10. Oculomotor activity: the co-ordination of eye and body movements, especially the hands.
11. Jules Romains, *La Vision extra-rétinienne et le sens paroptique* (Paris: Gallimard, 1964). First published in 1920, this work was ahead of its time and was re-issued in 1964. 'Experiments on extra-retinal vision show that certain lesions of the eye (strabismic amblyopia for example) cause the subject to reject consciousness: the eye keeps its qualities, the image manages to form on it, but this is repelled more and more insistently by consciousness, sometimes to the point of complete blindness.'
12. W. R. Russell and Nathan, *Traumatic Amnesia* (Brain, 1946). Studies of forms of traumatism suffered by returned soldiers.

13. M.-J. Deribere, *Préhistoire et histoire de la lumière* (Paris: France-Empire, 1979).
14. Correspondence with Claude Nièpce, 1816.
15. Edgar Allan Poe, *The Man of the Crowd* [First appeared in America in December 1840 in both *The Casket* and *Gentleman's Magazine*.]
16. Jack London, *The People of the Abyss* (London: Journeyman, 1977; originally published 1903). A report.
17. The Elpenor Syndrome, from the name of a hero of *The Odyssey* who fell off the roof of Circe's temple. Exercising normal automatic motor functions in waking up in an unfamiliar place, the subject was stricken with topographical amnesia. ... Because this often occurs on board fast transport, the General Secretary of the SNCF [French Rail], Vincent Bourrel, has called attention to the number of accidents resembling the historic one at the turn of the century when French President Deschanel fell from a train.
18. Albert Speer, *Inside the Third Reich* (London: Weidenfeld, 1970); *Spandau: The Secret Diaries* (London: Collins, 1976) [translation modified].
19. 'Pessoa et le futurisme portuguais', *Action poétique*, 110, winter 1987.
20. Gustave Lebon, *Enseignements psychologiques de la guerre européenne* (Paris: Flammarion, 1916).
21. As Jean Rouch was later to write about the Russian film-maker: 'The Kino Eye is Dziga Vertov's gaze ... left eyebrow down a little, nose tightly pinched so as not to get in the way of sight, *pupils open at 3.5 or 2.9*, but the focus on infinity, on vertigo ... way past the soldiers on the attack.' In a few millennia, we lost 'that *obscure faith in perception* which questions our mute life, *that combination of the world and ourselves which precedes reflection*'. Merleau-Ponty, *Le Visible et l'invisible* (Paris: Gallimard, 1964).
22. Watkins and Tulving, 'Episodic memory: when recognition fails', *Psychological Bulletin*, 1974.
23. *Libération*, 24 November 1987.
24. Gérard Simon, *Le Regard, l'être et l'apparance* (Paris: Le Seuil, 1988).
25. Quoted by Georges Roque in his essay on Magritte and advertising, *Ceci n'est pas un Magritte* (Paris: Flammarion, 1983).
26. 'L'art n'est plus justifiable ou les points sur les i', interview with Daniel Buren recorded by Georges Boudaille in *Les lettres françaises*, March 1968.
27. Merleau-Ponty, *L'œil et l'esprit* (Paris: Gallimard, 1964).

Chapter 2

Less Than an Image

In calling his first photographs of his surroundings 'points of view', around 1820, their inventor, Nicéphore Nièpce came as close as possible to Littré's rigorous definition: 'The point of view is a collection of objects to which the eye is *directed* and on which it *rests* within a certain distance.'[1]

Yet when you look closely at these first 'solar writings', what you notice is not so much the scarcely discernible, colourless objects as a sort of luminance, the conduction surface of a luminous intensity. The main aim of the heliographic plate is not to reveal the assembled bodies so much as to let itself be 'impressed', to capture signals transmitted by the alternation of light and shade, day and night, good weather and bad, the 'feeble autumn luminosity' that hampers Nièpce in his work. Later, but before photographs had been fixed on paper, the iridescence of the daguerreotype's metal plate was to be a talking point.

On 5 December 1829 Nièpce wrote in his note on heliography to Daguerre:

'*Fundamental principle of the discovery.*

'In the process of composing and decomposing, light acts chemically on bodies. It is absorbed, it combines with them and communicates new properties to them. In so doing it enhances the natural consistency of some bodies, even going as far as solidifying them, making them more or less insoluble depending on how long or intense its action is. This, in a nutshell, is the principle of the discovery.'

In retrospect Daguerre, a crafty showman who would dream till the end of his days of colour photography and instantaneity, appears to be one of many entrepreneurs obsessed with the imaging powers of heliographic mechanics and the legibility and commercialisation of the images produced. Artistic, industrial, political, military, techno-

logical, fetishist and other uses, from scientific research to the most banal representations of daily life, were all based imperceptibly on the principle of Nièpce's invention, with its photosensitivity to a world which, for him, was 'completely bathed in luminous fluid'.

In 1863 Alphonse Legros spoke of the 'Sun of the Photo'. Mayer and Pierson wrote: 'Words cannot describe the almost giddy infatuation that has taken hold of the Parisian public ... the sun rising each day only to find innumerable instruments levelled at in anticipation, everyone, from the scholar to the respectable burgher, having become experimenters under the influence.'[2]

With the birth of this latter-day sun worship, objects and solid bodies were eclipsed as the central subject of systems of representation by the plenitude of a certain energy, and the role and properties of this energy would never stop being demonstrated and developed from that moment on. Nineteenth-century physicists themselves promoted their work on electricity and electromagnetism using Nièpce's very metaphors as provisional expedients.

Having succeeded in producing the first aerial photograph in 1858 and in perfecting a kind of electric light that enabled him to take photographs at night, Nadar also referred to *that crucial feeling of light* since sunlight was the agent involved in producing a *supernatural etching*.

Supernatural action of light, the critical problem of the *time-freeze* of the photographic exposure lends daylight a temporal measure independent of the meteorological day. It produces a separation of light and time in a way that recalls the Biblical separation, source of all the visible world's virtualities.

On the first day the God of the Judeo-Christian tradition created light and darkness. It was not until the fourth day that he got down to the 'lighting equipment', to planets destined to govern the seasons and the activities of the living and serve man as reference points, signs and measures.

The incommensurable speed of time before time existed was celebrated by quite a number of poets in the sixteenth century, well before André Breton and the Surrealists came along, or the physicists who resurrected Genesis as a privileged theme of the modern scientific imagination.

These poets are little known today, difficult to get hold of, obscure, unjustly buried by the Classics. Marin Le Saulx is one. This is from his poem, *Théanthrogamie*:

This is the first night that has seen the sun
Bleach its black sails with its pale gold light.
I can truly say that this is the first night
That has made of midnight an incomparable noon. (...)

May this nightless night increase the number
Of other days of the year, may this night have no darkness,
And shine always with an eternal light.[3]

In *A Brief History of Photography* Walter Benjamin finds the same principle at work in cinema, as an extension of the snapshot. He notes: 'Cinema provides *matter* for simultaneous collective reception the way architecture has always done.' A mere accident of translation?

When the cinema auditorium is suddenly plunged into artificial darkness, its configuration, the bodies in it, dissolve. The curtain veiling the screen parts, repeating Nièpce's original rite of opening the aperture plate of the camera obscura *just a touch away from a tender virgin flash more momentous than all the constellations that are there for our eyes to feast on* (Tzara).

The *matter* provided and received in collective, simultaneous fashion by cinemagoers is light, the speed of light. In cinema, it would be even more appropriate to speak of *public lighting* rather than public image. The only other art to have offered this before is architecture.

From Nièpce's thirty minutes in 1829 to roughly twenty seconds with Nadar 1860, time may have exposed itself independently in the photograph, but it ticked away very slowly for its exasperated practitioners.

Disdéri writes: 'What remains to be done, I think ... is to speed up the process further; the ideal solution would be to obtain instantaneity.'[4] With photography, seeing the world becomes not only a matter of spatial distance but also of the *time-distance* to be eliminated: a matter of speed, of acceleration or deceleration.

Drawing a false analogy, photography's promoters were immediately persuaded that what the photograph had over the human eye above all was, precisely, its specific speed which, *thanks to the implacable fidelity of the instrument and at quite a remove from the subjective and distorting action of the artist's hand, enabled it to fix and reveal movement with a precision and a richness of detail that naturally elude the eye.*[5] The world, 'rediscovered' as an unknown continent, at last appeared in 'all its naked truth'.

In the autumn of 1917 Emile Vuillermoz wrote about *cinéma d'art*: 'The eye that *carves up* space and *fixes* inimitable tableaux in time, that *renders eternal* the fleeting moment in which nature reveals its genius ... is the eye of the lens.'

Considered irrefutable proof of the existence of an objective world, the snapshot was, in fact, the bearer of its own future ruin. In their day Bacon and Descartes may well have advanced the cause of a

certain experimental methodology and talked about *mnemonic practices* as devices useful in organising information. It would not have occurred to them to conceptualise such practices because, for them, it was a matter of familiar processes belonging to the realm of the self-evident.

But in multiplying 'proofs' of reality, photography exhausted it. The more instrumental photography became (in medicine, in astronomy, in military strategy ...), the more it penetrated beyond immediate vision, the less the problem of how to interpret its products managed to emerge from the déjà vu of objective evidence. And the more it reverted to the original abstraction of heliography, to its primitive definition, to that depreciation of solids whose 'contours are lost' (Nièpce) and to the emphasis on *point of view* whose innovative power painters and writers like Proust had grasped.

This drift of overexposed matter, reducing the reality-effect to the greater or lesser promptness of a luminous discharge, found a scientific explanation in Einstein's 'theory of viewpoint'. It was this theory that led to the Theory of Relativity and, in the long run, more or less destroyed anything connected with external proofs of a unique duration as a cogent principle for classifying events (Bachelard), the *thinking of being and the uniqueness of the universe* of the erstwhile philosophy of consciousness.

As we know, discoveries from Galileo to Newton had presented an image of a universe in which everything could be described, illustrated or reproduced by experiments and concrete examples. There was a shared faith in a world toiling away with comforting regularity before our very eyes and this produced a sort of incubation of vision and knowledge which only became more extensive with time.[6]

Photography likewise, in fulfilment of Descartes' hopes, had been largely an art in which the 'mind' dominating the machine interpreted the results in the fine tradition of instrumental reason.

But, conversely, because the technical progress of photography brought daily proof of its advance, it became gradually more and more impossible to avoid the conclusion that, since every object is for us merely the sum of the qualities we attribute to it, the sum of information we derive from it at any given moment, the objective world could only exist as what we represent it to be and as a more or less enduring mental construct.

Einstein took this reasoning to its logical conclusion by showing that space and time are *forms of intuition* that are now as much a part of our consciousness as concepts like form, colour, size and so on. Einstein's theory did not contradict classical physics. It simply revealed its limits which were those of any science linked to man's sensory experience, to the general sense of spatial relationships which the logistics of perception have been secretly undercutting since the Renaissance and especially since the nineteenth century.

The retreat from the mathematically derived mechanical explanation took time. Max Planck postulated quantum theory in 1900, 'quanta' being mathematical facts that cannot be accounted for. After that, as Sir Arthur Eddington remarked: 'every genuine law of nature stood a good chance of seeming irrational to the rational man.'[7]

These facts were difficult to accept for they not only went against cumulative scientific prejudice, they went equally against the dominant philosophies and ideologies.

This makes it easier to see why Einstein's theory was banned, why efforts to popularise it and communicate it to a wider audience were so sporadic, 'limiting and reducing the body of knowledge on the subject to a small, privileged group crushing the philosophical spirit of the people and leading to the gravest spiritual impoverishment', the physicist wrote in 1948. By reminding us that 'there is no scientific truth', in the middle of a century crawling with engineers, Einstein remobilised what fifteenth-century poets and mystics like Cues called *learned ignorance*; in other words the *presupposition of not-knowing* and especially *not-seeing* which restores to every research project its fundamental context of *prime ignorance*. Also he did this at a time when the alleged impartiality of the lens had become the panacea of an image arsenal which arrogated to itself the ubiquitous, *all-seeing power* of Theos in the Judeo-Christian tradition, to such an extent that it seemed, at last, that the possibility was being offered of *uncovering a fundamental structure of being in its totality* (Habermas), of finally defeating fanatical beliefs of all kinds including a religious faith that would then be reduced to a vague, private concept.

Benjamin exults: 'Photography prepares the salutory movement by which man and his surrounding world become strangers to each other … opening up the *clear field* where all intimacy yields to the clarification of details.' This *clear field* is the primary promotional field of propaganda and marketing, of the technological syncretism within which the witness's least resistance to the phatic image is developed.

To admit that for the human eye the essential is invisible and that, since everything is an illusion, it follows that scientific theory, like art, is merely a way of manipulating our illusions, went against the political-philosophical discourses then evolving in tandem with the imperative of convincing the greatest number, with its accompanying desire for infallibility and a strong tendency towards ideological charlatanism. Publicly to point to how mental images are formed, including the way their psychophysiological features carry their own fragility and limitations, was to violate a state secret of the same order as a military secret, since it masked a mode of mass manipulation that was practically infallible.

This, by the way, also accounts for the itinerary of the whole host of materialist philosophers like Lacan, passing prudently from the image to language, to the linguistic being, who have dominated the

intellectual scene for close on half a century, defending it as though it were a citadel, forbidding any conceptual opening, and deploying, to this end, massive reinforcements in the form of Marxist-Freudian babble and semiological cant.

Now the damage is done, the often fatal quarrels which, until quite recently, surrounded different modes of representation – in Nazi Germany and the Soviet Union, and also in Great Britain and the United States – have been all but buried.

To find out how they worked, though, one only has to read Anthony Blunt's memoirs, a real little *roman à clef*. A renowned expert, Professor and connoisseur, as well as a distant relative of Queen Elizabeth ll, Blunt was one of this century's most remarkable secret agents in the service of the Soviet Union. And his political choices were absolutely consistent with the evolution of his artistic tastes, the beliefs he held about systems of representation.

As an undergraduate Blunt initially saw 'modern art' as a means of venting his hatred of the Establishment. In the twenties, Cézanne and the Post-impressionists were still considered in Great Britain to be 'mad revolutionaries'. But in the course of the 1933 university term, Marxism broke out at Cambridge.

Blunt then completely revised his position. Art could no longer cling to *optical effects*, to an individualist and therefore relative vision that shed doubt on the objective legibility of the universe and produces metaphysical anxiety. From now on the end of all logocentrism will be called 'revolutionary', 'a community-based and monumental social realism'.

It is interesting to note that at the same moment, and in response to the nationalisation of Soviet cinema, a *documentary school* sprang up in Britain, also sustained by then-burgeoning socialist theories.

This movement, which was to have considerable international influence, crystallised around the Scot John Grierson. For Grierson, as for Walter Lippmann, democracy was 'scarcely achievable without information technology on a par with the modern world'.

After a tough time spent on minesweepers in the First World War, Grierson had become 'Film Officer' with the Empire Marketing Board. This organisation, founded in May 1926, was designed to promote trade in Empire goods. The Film Unit was at that stage the last sub-department in the 'Publicity and Education' Department. The secretary of the whole colonial-promotions group was top civil servant Stephen Tallents. The situation thus presented an extraordinary conjunction of all the symptoms of acculturation: colonisation and endocolonisation and the use of advertising and propaganda for the edification of the masses. It was moreover at the Dominions Office, and thanks to Rudyard Kipling's and Stephen Tallents' support, that

24

top civil servants in the administration met with a representative of the Treasury and ended up agreeing, on 27 April 1928, to an advance of £7,500 to finance an experiment in film propaganda whose subject would be England itself. According to the brains behind it, this new documentary thrust, subsidised by the State and conceived as a public service, grew out of a vast anti-aesthetic movement (as one might have guessed) and as a reaction against the art world. It was also an aggressive response to the lyricism of the Soviet propaganda film, particularly Eisenstein's *Battleship Potemkin*.

Where role model Robert Flaherty had created an ethnological cinema that was universally popular, the film-makers of the British Documentary Movement, emerging from the mass war of 1914, wanted to put together an *anthology of public vision*. They had understood that photography and film – in so far as they are the memory, the trace not only of historical events, but also of anonymous extras with whom one could easily identify – provoked a specific emotion in the viewer. The images were those of the *fatum*, of something done once and for all. They exposed time, induced a feeling of the irreparable, and through a dialectic reaction, fostered that violent will to engage the future which was invariably weakened by any apparent mise en scène, any aesthetising discourse.

During the 1930s the Documentary Movement continued to be influenced politically by men such as Humphrey Jennings, freshly fired in the revolutionary furnace of Cambridge, the communist politician Charles Madge and the anthropologist Tom Harrisson, prime movers in the left-wing Mass Observation movement.

They all believed in the ineluctable progress of technology, in a *technically 'liberated cinema'*. In August 1939 Grierson wrote that 'the documentary idea should simply enable everyone *to see better'*.

On the eve of the Second World War the bloody media epic of the Spanish Civil War was to demonstrate further the power of the anthological cinema. Republican fighters went as far as losing whole battles in their keenness to live out a faithful remake of the Russian Revolution as they had seen it at the movies. Throwing themselves in front of the camera in the same poses as their Russian models, they felt themselves to be actors in a great revolutionary epic.

'Truth is the first casualty of war', in Rudyard Kipling's paradoxical phrase. Kipling was one of the founders of the British Documentary Movement and it was definitely the *reality-principle* they sought to attack. The movement succeeded in overpowering the vaguely elitist dogma of the objectivity of the lens, replacing it with the equally – though differently – perverse dogma of the camera's innocence.

'Beauty changes quickly, much as a landscape constantly changes

with the position of the sun.' What Rodin asserted empirically, according to Paul Gsell, began to find some semblance of scientific confirmation fifty years on.

In the 1950s, as the great dominant ideologies began their decline, physiology and psychophysiology abandoned the archaic methodological attitude that had so astounded Maurice Merleau-Ponty, the Cartesian refusal to let go of the body, that had degenerated into mere convention.

Since the 1960s one discovery after another in the field of visual perception has revealed that light detection, and the intensity of the reaction to light stimuli and ambient light, have a molecular basis. Molecules, those *internal lights*, apparently 'react the same way we do when we are listening to music'.

On top of this scientists have rediscovered biological rhythms, biorhythms, perfectly familiar to breeders, botanists and the common gardener for centuries. ... As far back as the sixth century BC, for instance, the philosopher Parmenides held that mental images, our memory, resided in a unique relationship between light and heat, cold and dark, located in the centre of our bodies. If this relationship were disturbed, amnesia, the forgetting of the visible world, resulted.

Professor Alain Reinberg explains: 'Each living being adapts itself to periodic variations in the world around it, these variations being essentially caused by the rotation of the earth about its axis every twenty-four hours and by its rotation around the sun every year.'[9]

It is as though the organism possessed 'clocks' (for want of a better word) and kept setting them back at the right time in terms of signals coming from the environment, one of these essential signals being the alternation between darkness and light, night and day, as well as noise and quiet, heat and cold, etc.

Nature thus provides us with a sort of programming (here again, the term is merely provisional) that regulates our periods of activity and rest, each organ working differently, more or less intently, all in its own good time. Our bodies in fact contain several *clocks* that work things out among themselves, the most important being the hypothalmic gland located above the optic commisure (where the optic nerves cross). The same thing happens with the pineal gland, which depends largely on the alternation of light and dark. The Ancients were familiar with the phenomenon and Descartes, in particular, talks about it.

In short, if the Theory of Relativity maintains that the intervals of time properly supplied by clock or calendar are not absolute quantities imposed throughout the universe, the study of biorhythms reveals them to be the exact opposite: a variable quantity of sensa (primary sensory data) for which an hour is more or less than an hour, a season more or less than a season.

This places us in a somewhat different position from that of 'bodies

inhabiting the universe' (to be is to inhabit, Heidegger's *buan*). Very much in keeping with certain ancient cosmogenies, like irisation, we become *bodies inhabited by the universe, by the being of the universe.*

Sensa are not only a more or less exact, more or less pleasurable or coherent way of informing ourselves about the external environment, as well as a means of acting and existing in it, not to mention occasionally dominating it. They are also messengers of our internal environment, which is just as physical and just as relative because it possesses its own laws. This situation of exchange of course ceases with our organic life, the universe that was busy sending out signals before we arrived then carrying on without us.

With chronobiology, as in physics, a living system appears and, contrary to what Claude Bernard or the advocates of homeostasis thought, it does not tend to stabilise its various constants in order to return to a determined equilibrium. The system, is 'always far for equilibrium'. For it, according to Ilya Prigogin, *equilibrium is death.* (Paul de Tarse imagined a being in a perpetual state of becoming far from fulfilment for whom the equilibrium of reason would resemble death.)

The Renaissance quest to overcome distances, all kinds of distances, would once again lead to the elimination of intervals, and our own movement in the time of the universe was to be singularly transformed by acknowledgement of this internal/external couple always far from equilibrium. Furthermore, this occurred at a time when Marxist and other philosophers were finally getting down to the serious job of revision, rather late in the day, scratching their heads over 'the hopeless perversion of the ideals of the Enlightenment and the demise of a philosophy of consciousness that posited an isolated subject in relation to an objective world that could be represented and changed'. This was the exhaustion of that Cartesian tradition which had sprung out of the original invention of the serialisation not only of forms-images but also of mental images and which was the origin of the City and human social communities based on the constitution of collective paramnesias, on the 'ideal of a world essentially the same, essentially shared as that preliminary foundation of the construction of meaning (*Sinnbildung*) we call geometry'.[10] Everyone, in fact, in their own way, is living out the end of an era.

My friend, the Japanese philosopher Akira Asada, said to me the other day: 'All in all, our technologies have no future, only a past.' But what a past!

They say Futurism could only have sprung up in Italy, *the one country where only the past is current*, and it was the Mediterranean Marinetti and his group who elaborated the theme of *movement in action*. But a number of good, solid European philosophers, on the other hand, have pretty much forgotten the fundamental relationship that exists between *tekhne* (know-how) and *poiein* (doing). They

27

have forgotten that the *gaze of the West* was once also the gaze of the ancient mariner fleeing the non-refractive and non-directional surface of geometry for the open sea, in quest of unknown optical surfaces, of the sight-vane of environments of uneven transparency, sea and sky apparently without limits, the ideal of an essentially different, essentially singular world, as the initial foundation of the formation of meaning.

The ship, being fast, was in fact the great technical and scientific carrier of the West. At the same time, it was a mix in which two absolute forms of human power, *poiein* and *tekhne*, found themselves working together.

In the beginning, there were no navigation maps, no known destinations, only 'Fortune fleeing like a prostitute, bald from the back'. At the mercy of the winds and the pull of the currents, the vessel inaugurated an instrumental structure which at once tested and clearly reproduced destiny's *always far from equilibrium*, its latency, its eternal unpredictability, exalting through these man's capacities for reaction, courage and imagination.

According to Aristotle, *there is no science of the accident*. But the ship defines another power, in the face of what might arise: the power of the unexplored side of the failure of technical knowledge, a poetics of wandering, of the unexpected, the shipwreck which did not exist before the ship did; and beside this, very much alongside it, that stowaway, madness: the internal shipwreck of reason for which water, the fluid, remains a utopian symbol throughout the centuries.[11] And since for the Ancient Greeks apocalypses and events in the making are the inconstant gods, the ship takes on a sacred character: it becomes associated with the military, religious and theatrical liturgies of the City.

From Homer to Camoëns, Shakespeare and Melville, the power of *movement in action* continues to be incorporated into a metaphysical poetics which becomes a sort of telescoping in which the painter or poet disappears into their work; the work disappears into the world it evokes since the perfect work induces the desire to live in it.[12] But the West's 'wings of desire' are sails, oars, a whole apparatus, a technical know-how which, in perpetually perfecting means-end relationships, in shifting its very rules, never ceases to swamp the unpredictable rules of the poetic accident.

From Galileo, pointing his telescope towards the sea's horizon and the vessels of the Venetian Republic before turning it on the sky, to William Thomson in his nineteenth-century yacht, with his relative measurement of time and kinetics, currents and waves, the continuous and the discontinuous, vibrations and oscillations ... *tekhne* and *poiein* have worked together. Maritime metaphors have continued to spur on, providing a way round the physical and mathematical stumbling blocks encountered by researchers who, in the time-honoured

expression, 'sail the unexplored seas of science' and who are still, often, also musicians, poets, painters, craftsmen of genius, navigators.

Paul Valéry writes: 'Man has extended his means of perception and action much more than his means of representation and summation'. But for the Italian Futurists the latest means of action are means of representation at the same time. They saw every vehicle or technical vector as an idea, as a vision of the universe, more than its image. Italian *aeromythology*, with aeropoetry soon followed by aerosculpture and aeropainting in 1938, is a new fusion-confusion of perception and object which already foreshadows video and computer operations of analogous simulation. It also revitalises the technical mix of origins, the aeroplane, and more especially the seaplane, taking the place of the ship of nautical mythology.

Gabriele D'Annunzio dedicated a short text celebrating the *consanguinity of man and the machine* to his recordbreaking friend Francesco de Pinedo. He called it 'Francesco de Pinedo's wings versus the wheel of fortune': 'The Venetian model of the war and trade ship hung over our heads. Being, like you, an aviator and a sailor, I could not hide my elation in front of you as, in defiance of fortune, I listed the instruments on board ... I liked you, as the Florentine liked Agathocles the Sicilian who never, in all his admirable life, owed a thing to fortune but to himself alone, to his own wisdom, to his audacity and constancy ... as well as to his art: the art of resisting, insisting, conquering.'[13]

After sundry adventures in the interests of war as much as sport, the Marchese de Pinedo ended up killing himself in September 1933, on the eve of his attempt to beat the world record for long-distance flight *in a straight line*.

The original voyage has been replaced by the trajectory of motor power. To a large extent, the former appeal of the enigma of technical bodies has vanished with it. Until quite recently, this had never been altogether absent from their use, from their plasticity and the imaginary of their beauty.

'If it works, it's obsolete!' Formulated during the last world war, the famous saying of Lord Mountbatten, then head of British armaments' research, signalled the irresistible encroachment of one last mythology. Technoscience, science's greatest weapon, is an introverted mix in which origin and end telescope together. By such a sleight of hand, the English navigator evacuates the innovatory power of the old *poiein* in favour of the dynamics of madness and terror which remain technology's final, eternally clandestine fellow-traveller.

Again the debate surrounding the invention of the snapshot is not unrelated to the growth of this ultimate hybrid. From the beginning of the nineteenth century, it had been radically transforming the very nature of representational systems which still held, for many artists

and art lovers, the lure of mystery, of a sort of religion (Rodin). Well before the triumph of dialectic logic, the arts were already laboriously ploughing on towards synthesis, towards overtaking the existing oppositions between *poiein* and the technical. Ingres, Millet, Courbet and Delacroix used photography 'as a reference and point of comparison'. The impressionists, Monet, Cézanne, Renoir, Sisley, made themselves known by showing their work in the studio of the photographer Nadar. They were heavily influenced by the scientific research of Nadar's friend Eugène Chevreul, especially the treatise published in 1839: *On the law of simultaneous colour contrast and the classification of coloured objects according to this law as it relates to painting.*[14]

Degas, who considered the model, the woman, to be 'an animal' (a laboratory animal?), vaguely adopted the vision of the camera. 'Until now, the nude has always been represented in poses that *presuppose an audience.*' Degas, by contrast, claimed simply to 'surprise' his models and provide a document as immutable as a snapshot – as much a *documentary* as a painting, in the strict sense of the term.

At the beginning of the twentieth century, with Dada and the Futurists, the world was heading towards complete depersonalisation, primarily of the thing observed but also of the observer. The dialectical play between the arts and sciences was being progressively eroded, making way for a *paradoxical logic* which prefigured the delirious logic of technoscience. We could even read into Mountbatten's motto a dim commentary on the pivotal concept behind artistic and intellectual avant-gardes, a concept differing greatly from the notion of modernity which goes back as far as Ancient Egypt.

Just when traditional systems of representation were about to lose their 'perfectibility', their specific capacities for evolution and change, Adolf Loos decided to compare cultural evolution to an *army on the march*, an army consisting mainly of stragglers. 'I may well be living in 1913', he writes, 'but one of my neighbours is living in 1900, the other in 1880. The peasant of the upper Tyrol is stuck in the seventh century.'

Under attack at the same time from Marcel Duchamp, European avant-gardes did, in fact, move around from city to city, indeed from continent to continent, like an army, to the beat of the progress of industrialisation and militarisation, of technology and science, as though art were now no more than the ultimate transportation of the gaze from one city to the next.

After the Napoleonic debacle, London and Great Britain (which gave us steam and industrial speed) took over the traditional post once occupied by Italy and the Eternal City as site of artistic pilgrimage. Paris and France (which gave us photography, cinema and aviation) then took over from them, only to be ousted in turn by New York and the United States, victors triumphant of the last world war.

Today, the strategic value of speed's 'no-place' has definitely out-stripped the value of place. With the instantaneous ubiquity of teleto-pology, the immediate face-to-face of all refractory surfaces, the bringing into visual contact of all localities, the long wandering of the gaze is at an end. In the new public sector the poetic carrier has no further raison d'être; no longer needed, the West's 'wings of desire' have folded up and Adolf Loos' metaphor of 1908 takes on another meaning. The delineation between past, present and future, between here and there, is now meaningless except as a visual illusion, even if, as Einstein wrote to his friend Michele Besso's family, the latter is a bit prim.

Malevich said it all at the beginning of the century: 'The universe is spinning in a pointless vortex. Man, too, for all his little objective world, is spinning in the limbo of the pointless.'

Malevich, Braque, Duchamp, Magritte. ... Those who continued to take their bodies with them – painters or sculptors – ended up elaborating a vast theoretical tract, in compensation for the loss of their monopoly on the image. This, in the end, makes them the last authentic philosophers, whose shared, obviously relative vision of the universe gave them the jump on physicists in new apprehensions of form, light and time.

Notes

1. Correspondence between Nicéphore and Claude Nièpce.
2. Mayer and Pierson, *La Photographie. Histoire de sa découverte* (Paris: 1862).
3. *Action poétique*, no. 109, Autumn 1987.
4. André Rouillé, *L'Empire de la photographie* (Paris: Le Sycomore, 1982).
5. André Rouillé, *ibid.*
6. Lincoln Barnett, *The Universe and A. Einstein* (1948).
7. This recalls Einstein's clocks and rulers: for instance, a clock (either spring-loaded or an hour glass), connected to a system in motion, works at a different pace from an immobile clock. A standard ruler (wood, metal or rope), connected to a system in motion, changes in length in relation to the speed of the system and so on. An observer moving at the same time would not perceive any change, but an observer standing still in relation to the systems in motion would notice that the clock slows down and the ruler contracts. The odd behaviour of clocks and rulers in motion is linked to the constant phenomenon of light.
8. 'L'Angleterre et son cinéma', *Cahiers d'aujourd'hui* 11, February-March 1977.
9. 'Le jour, le temps', *Traverses*, 35, 1985.
10. Husserl, *L'Origine de la géométrie* (Paris: PUF, collection 'Epiméthée').

11. See J.-P. Vernant, *La Mort dans les yeux* (Paris: Hachette, 1986) on Medusa and the proximity of the empire of terror, unbridled madness and inspiration, Pegasus born of the beheaded Gorgon.
12. François Cheng, *Vide et plein. Le langage pictural chinois* (Paris: Le Seuil, 1979).
13. Francesco de Pinedo, *Mon vol à travers l'Atlantique* (Paris: Flammarion).
14. Huygens also had a great influence on impressionist art with his hypothesis concerning the behaviour of light waves.

Chapter 3

Public Image

Well after the Sun King stung Colbert into action with his dictum: 'Let there be Light and Security!', well before the Nazi theorist Rosenberg delivered his extravagant aphorism: 'When you know everything you are afraid of nothing', the French Revolution had turned the elucidation of details into a means of governing.

Omnivoyance, Western Europe's totalitarian ambition, may here appear as the formation of a whole image by repressing the invisible. And since all that appears, appears in light – the visible being merely the reality-effect of the response of a light emission – we could say that the formation of a total image is the result of illumination. Through the speed of its own laws, this illumination will progressively quash the laws originally dispensed by the universe: laws not only governing things, as we have seen, but bodies as well.

At the end of 'Day One' of the 1848 Revolution, appropriately, witnesses testified that in different parts of Paris, independently of each other, people shot up public clocks, as though instinctively determined to stop time just as darkness was about to fall naturally.[1] 'Obeying the law is suspect', asserts Louis de Saint-Just, one of the leading promulgators of the terror-effect. With the perfectly French invention of revolutionary terror – domestic as well as ideological – the scientific and philosophical genius of the land of the Enlightenment and supreme rationality topples over the edge into a sociological phenomenon of pure panic.

It was at this moment that the revolutionary police chose an eye as its emblem; that the invisible police, the police spy, replaced the evident, dissuasive police force; that Fouché, the orator and former monk, confessor to the sinner, set up a camera obscura of a different kind, the famous cell in which the correspondence of citizens under suspicion was deciphered and exposed. A police investigation that

aimed to illuminate the *private sphere* just as the theatres, streets and avenues of the *public sphere* had previously been illuminated, and to obtain a total image of society by dispersing its dark secrets. A permanent investigation within the very bosom of the family, such that anything communicated, the tiniest shred of information, might prove dangerous, might become a personal weapon, paralysing each individual in mortal terror of all the rest, of their spirit of inquiry.

Remember that in September 1791, on the eve of the Terror, the Constituent Assembly, which was to disappear the following month, had instituted the *Criminal Jury* as an agent of justice whereby citizens, as members of the jury, acquired sovereign authority with the power to sentence a person to death without appeal. (In legal parlance, this is a double-degree move.) The people and their representatives were thus granted the same infallibility as the monarch by divine right they were supposed to replace. It would not be long before *common justice* showed the flaws Montaigne had described two centuries earlier: 'A heaving sea of opinions ... forever whipped up ... and driven on by customs that change with the wind. ...'

Curiously, the terror-effect's atavistic twin nature – its obsession with the un-said going hand in glove with a totalitarian desire for clarification – is to be found at work endlessly and excessively in Fouché or Talleyrand. But also, later, much later, in the terrorising and terrorised knowledge of the Lacan of *Je ne vous le fais pas dire!*, in the Michel Foucault of *Naissance de la clinique* and *Surveiller et punir*, in the Roland Barthes of *La Chambre claire* and the Barthes-inspired exhibition 'Cartes et figures de la Terre' at the Pompidou Centre. Barthes would write in conclusion to a life of illness and anguish: 'Fear turns out to have been my ruling passion'.

One could discourse endlessly about 'The declaration of the rights of man and the citizen' and the conquest of power by the middle-class military democracy. But it is just as important not to detach the people's revolution from its means, from its everyday materials and depredations. The Revolution as social disease speaks of a banal, sometimes ignominious death. But beyond this, on the internal battlefront, with the supremely warrior-like scorn for the living and the Other that we find in both opposing camps, the Revolution will spread the new materialist vision in the wake of its victorious armies. And this vision will overthrow the entire set of systems of representation and communication in the course of the nineteenth century. The real significance of the 1789 revolution lay here, in the invention of a *public gaze* that aspired to a *spontaneous science*, to a sort of knowledge in its raw state, each person becoming for everyone else, in the manner of the sans culotte, a benevolent inquisitor. Or, better still, a deadly Gorgon.

Benjamin was later to rejoice that 'cinemagoers have become examiners, but examiners having fun'. If we turn the phrase around, things

look a bit less promising: what we are now dealing with is an audience for whom the investigation, the test, has become fun. Actions spring from terror, events that embody the new passion, like stringing people up from lampposts, brandishing freshly lopped heads on spikes, storming palaces and hotels, seeing that residents' names are posted on the door of apartment blocks, reducing the Bastille to rubble, desecrating convents and places of worship, digging up the dead. . . . Nothing is sacred any more because nothing is now meant to be inviolable. This is the tracking down of darkness, the tragedy brought about by an exaggerated love of light.

What about the little quirks of David, the painter and member of the Convention; his penchant for the bodies of victims of the scaffold; the sordid sequel to the execution of Charlotte Corday; the dark side of his celebrated painting 'The Death of Marat'. Remember it was Marat, 'the people's friend' and an absolute maniac for denunciation, who, in March 1779, presented a paper to the Académie des Sciences entitled 'Monsieur Marat's discoveries concerning fire, electricity and light' in which he singled out Newton's theories in particular for attack.

The French Revolution was preoccupied with lighting, notes Colonel Herlaut. The general public, we know, craved artificial lighting. They wanted lights, city lights, which had no further truck with Nature or the Creator, which just involved man illuminating himself. This coincided with the precise moment when man's being was becoming his own object of study, the subject of a positive knowledge (Foucault). The rise of the fourth estate occurs here, within the shimmering urban mirage that is merely the illusion of what is up for grabs.

'Better to be an eye', as Flaubert would say, taking up the slogan of the revolutionary police. In fact, the Revolution ushered in that collusion between the man of letters, the artist and the man of the press, the investigative journalist-informer. Whether Marat or the Hébertiste 'Père Duchesne', the trick is to hold the attention of the greatest number through anecdote, the *fait divers*, the political or social-crime story.

Despite its wild excesses, revolutionary journalism aims *to enlighten* public opinion, to make revelations, to delve behind deceptive appearances, to provide slowly but surely a convincing explanation for every mystery, in keeping with the demands of a public full of examiners.

In 1836 a new partner emerged and a decisive cartel was formed.

35

Thanks to Emile Girardin the press finally achieved mass circulation by rationally exploiting advertising revenue, thereby succeeding in lowering subscription rates. And in 1848, as the romantic revolution is winding down, the *serial novel* takes off.

That same year, Baudelaire discusses the great writers of the eighteenth and early nineteenth centuries, such as Diderot, Jean Paul, Laclos and Balzac, in terms of their preoccupation with an eternal *supernaturalism* having to do with the *primitive nature* of their probe, with the new inquisitorial spirit, the *spirit of an examining judge*. Following spiritual ancestors like Voltaire, who conducted his own investigations into a number of criminal cases (advocating the rehabilitation of Jean Calas, for example, or Sirven, or defending Count Lally-Tollendal in the Lally-Tollendal Affair), Stendhal published *Le Rouge et le noir* in 1830, unsuccessfully, only two years after the Berthet Affair had been splashed across the Grenoble newspapers.

With the emergence of a press of informers, it was only natural that scientific thought, then in the throes of objectivism, should impose its methods and standards on the new inquisitorial literature. This is particularly marked in Balzac. Balzac was fascinated by the way the police viewed society, by police reports, by Vidocq's tales. He was also fascinated, at the same time, by paleontology, by the *law of subordination of organs*, Cuvier's law of the *correlation of forms*, etc. Naturally he would fall in love with the 'latest great discovery': the photographic impression (see *Le cousin Pons* 1847).

Though the claim that *The Murders in the Rue Morgue* (1841) was the first modern detective story is a bit excessive, Edgar Allan Poe, who was perfectly familiar with Balzac's works, felt the ideal investigator had to be French, like Descartes. Although he never once set foot in Paris, the author of *The Purloined Letter* kept very much abreast of what was happening there. His Charles-August Dupin, the model for all future fictional detectives, was probably none other than the Paris Polytechnique graduate and research scientist, Charles-Henri Dupin. As for the mandatory example of Descartes, we know that the author of *Discours de la méthode* once solved a crime in which one of his neighbours was implicated by assiduously disentangling the psychology involved. (He alludes to the episode in a letter to Huygens dated January 1646).

Flaubert took the innovation of the novel's conversion into case study to new heights. In his essay on Flaubert, Guy de Maupassant writes: 'First of all he imagines types, then, proceeding by deduction, he makes these beings perform actions typical of them and which they are doomed to carry out absolutely logically according to temperament.'

The instrumentalisation of the photographic image is not unrelated to this literary mutation. Before establishing a photographic encyclopædia of his contemporaries, Nadar (who once worked for the

French secret service), with his brother, became interested in the work of the celebrated neurologist Guillaume Duchenne whose major study, complete with supporting photographic documentation, was eventually published as *The mechanics of human physiognomy, or an electro-physiological analysis of the expression of the passions*.

This was in 1853. *Madame Bovary* was to appear four years later. In it Flaubert dismantles the passions mechanically à la Duchenne and leaves no doubt whatever about his own methods: before working up what he calls scenarios of novels 'analysing psychological cases', and 'since everything one invents is true', he conducts intricate investigations and cross-examinations, going as far as extorting embarrassing confessions as in the Louise Pradier case. In the same spirit, he thought it was only fair to claim the sum of 4,000 francs from his publisher Michel Lévy for the costs of investigations relating to *Salammbô*.

But apart from what it owes to the documentary and the lampoon, Flaubert's real art has to do with the light spectrum. For Flaubert, the organisation of mental images is a subtractive synthesis that ends in a coloured unity: golden for the exotic *Salammbô*, mildewy for *Madame Bovary*, the colour of small country towns and the dull sheen of romantic thought active in France after the 1848 Revolution.

What we might call the conceptual framework of the novel is thus deliberately reduced to the encoding of a dominant, quasi-unconditional stimulus, the target attribute destined to act beyond the bounds of literature itself and designed to lead the reader to a kind of 'optical retrieval' of the meaning of the work.

This brings us dangerously close to impressionism, and the *succès de scandale* enjoyed by *Madame Bovary* anticipates that of the *exposition des refusés* held at Nadar's.

Meanwhile Gustave Courbet cites Géricault (along with Prud'hon and Gros) as one of the great precursors of the new *art vivant*, largely due to his having chosen to paint contemporary subjects.

In 1853 Gustave Planche, in his *Portraits d'artists*, also paid homage to the forgotten works of the painter of 'The Raft of the Medusa'. 'No-one', Klaus Berger remarks, 'was interested in making what he had to say known after his death in 1824, least of all the Romantics, like Delacroix, who owed his beginnings to the young Géricault.'[2]

So Géricault emerges from oblivion at the precise moment that the photographers are dreaming of absolute instantaneity, that Dr Duchenne of Boulogne, sending an electric current through the facial muscles of his subjects, claimed to seize photographically the mechanism involved in their movement. The painter suddenly found himself a precursor, since, well before Daguerre's process was unveiled before the general public, the compression of time that visual instantaneity represents had become the undying passion of his short life. Well

before the impressionists, Géricault considered *immediate vision* an end in itself, the very substance of the work and not merely a possible starting point for a 'more or less fossilised' academic painting.

Géricault's *art vivant* was already an *art that evolves by summing itself up* such as Degas would later describe: an art of reiteration, like everything else that communicated and conveyed itself at constantly increasing speed from the nineteenth century on.

In 1817 Géricault got to know the doctors and nurses at Beaujon Hospital next to his studio. They supplied him with corpses and sawn-off limbs and let him stay in the hospital wards to follow every phase of the suffering, and death pangs of the terminally ill. We also know of his relationship with Dr Georget, the founder of social psychiatry and a court expert to boot.

It was at the instigation of this celebrated specialist in mental health that he completed his 'portraits of mad people' in the winter of 1822, which were to serve as visual aids for the doctor's students and assistants. 'A transmutation of science into eloquent portraits' was how they were described at the time. It is perhaps more apt to call them the artist's conversion of the clinical sign to enhance the painted work which then becomes a documentary, an image loaded with information: the conversation of a *perception of the special detachment* that enables the doctor or surgeon to make a diagnosis simply by using his senses and repressing any emotion due to the effects of terror, pity or repulsion.[3]

Some time before this, driven as always by his passion for the immediate, Géricault had conceived the project of painting a recent news story. For a while he toyed with the *Fualdès Affair*, popularised in the press and cheap prints. Why did he finally opt for the tragedy of the *Medusa*? I personally think it is incredible that the name of the ship that went down was precisely the same as in the Gorgon myth. 'To behold the Gorgon,' writes Jean-Pierre Vernant, 'you must look into her eyes and when your eyes meet, you cease being yourself, cease living and become, like her, a power of death.' The Medusa is a kind of *integrated circuit of vision* that would seem to bode a future of awesome communication. And just to round off this case for permeation, there was Géricault's passion for the *horse-as-speed*. This would be one of the agents of his death; with Pegasus, it furthermore constitutes an essential element of the ancient Gorgon imagery (at once the face of terror, the incarnation of fright and the source of poetic inspiration).

For his painting 'The Raft of the Medusa' Géricault began preparatory work and research in 1818, less than two years after the tragedy occurred, starting with the way the catastrophe was related in the press and in a book which went into several editions, all eagerly snapped up by the public. Géricault met survivors of the shipwreck, notably Dr Savigny; he had a model of the raft made up and did

numerous studies using dying patients in the hospitals next door as models along with corpses in the morgue.

But apart from all that, which we know about, the monumental dimensions of the picture – thirty-five square metres – tell us something about Géricault's intentions. He clearly wanted to capture the attention of the general public, not so much in his capacity as an artist, but in the manner of a journalist or advertising executive. Before hitting on the solution of giganticism, he first thought of doing a *painting series*, a 'painting in episodes' that would evolve over time (bit like Poussin's sketches based on the figures of Trajan's Column).

In the end he decided he could overcome pictorial representation's media handicap by enlarging the spectator's visual field, the size of the work begging the question, by reversing it, of the space in which the image could be shown. This *crowd painting* obviously could not, through its sheer size, be hung anywhere other than in some vast public place (a museum?). Unlike an easel painting, which could adapt to domestic intimacy, unlike the frescoes and monumental paintings commissioned in the Renaissance, which then spread out after the fact over the walls of the various palaces and churches, Géricault's painting was a work looking for a place to hang.

As soon as it was unveiled, in all its internal contradictions, it met with hostility from painters of all persuasions, critics and art lovers alike. On the other hand, it was a sensation with the general public who saw it not so much as a work of art as a pamphlet designed to discredit the government of Louis XVlll. The royal administration, accused by the opposition of being indirectly responsible for the tragedy, had in any event made the first move by banning the use of the name *Méduse* in the exhibition leaflet. But as Rosenthal writes: 'the public was able to work out the original name without too much trouble and political passions ran riot'. In such a climate there was no question of the State's buying it or of its being hung in some official space or museum.

Rolled up in Paris and shipped to England, the outsize painting was finally shown from town to town as far as Scotland, for the price of a ticket. Organised by one Bullock, the venture was to earn Géricault the enormous sum of 17,000 gold sovereigns, a fortune in keeping with its popular success.

But well before the symbolic *Medusa*, pictorial art in Great Britain had been veering towards the mercantilism of the sideshow.

In 1787 the Scottish painter Robert Barker had taken out a patent for what he called 'nature at a glance.' This would later be known as a panorama. What made the panorama such a runaway success was the fact that it brought a pictorial work and an architectural construct together, as Quatremère de Quincy indicates in his *Dictionnaire historique de l'architecture* (1832):

'Panorama: The term sounds as though it should belong exclusively

to the language of painting, for it combines two Greek words to signify *complete view*. This is obtained by means of a circular background on which a series of aspects are drawn and then rendered, uniquely, by a series of separate paintings.

'Now it is precisely this condition, which is indispensable to this genre of representation, which makes an architectural work of the painter's field of activity. The name panorama, in fact, refers both to the edifice on which the painting is hung and to the painting itself.'

Quatremère describes the building as a rotunda with daylight entering from above, the rest of the building remaining dark. Viewers were led into the centre along long, dark corridors so their eyes would adjust to the dark and register the light on the painting as natural. Coming on to a raised amphitheatre in the middle of the rotunda in the dark, viewers had no idea where the light was coming from. They could not see either the top or the bottom of the painting which revolved around the circumference of the building, offering no beginning or end, in fact no boundary whatever. It was like being on a mountain with the view obstructed only by the horizon.

In 1792 Robert Barker showed 'The English Fleet at Portsmouth' in his Leicester Square rotunda. The American Robert Fulton, who was responsible for the first submarine and the industrialisation of steamship propulsion, bought the rights for the commercial use of the patent in France. Fulton gave Paris its first rotunda in the boulevard Montmartre. After that similar constructions sprang up all over Paris offering *pictorial spectacles*: battle scenes, historic events, exotic urban sites like Constantinople, Athens, Jerusalem, and painted in lavishly minute detail.

'In Paris I saw panoramas of Jerusalem and Athens', Chateaubriand writes in the preface to his Complete Works. 'I recognised all the monuments immediately, every building, right down to the tiny room I stayed in in Saint-Sauveur Convent. *No traveller has ever endured a rougher ordeal: how was I to know they were going to bring Jerusalem and Athens to Paris?*'

The new inertia of the traveller-voyeur was to be further attenuated by Daguerre when he turned his *Diorama* construction in the rue Samson, behind the boulevard Saint-Martin, into a *veritable sight travel machine*.

In this structure, which was built in 1822, *The viewers' room was mobile* and spun round like a one-man-operated merry-go-round. Everyone found themselves carried around past all the paintings on show without apparently having to move a muscle.

Panoramas and dioramas were enormously successful, the profits fabulous. Deeply admiring, the painter David took his students to a panorama on the boulevard Montmarte. In 1810 Napoleon slipped into a rotunda on the boulevard des Capucines and came out dreaming of using the hit show as an instrument of propaganda.

'Napoleon engaged the architect Célérier to draw up plans for eight rotundas to be erected in the great square on the Champs-Elysées; in each, one of the great battles of the Revolution or Empire was to be shown. ... The events of 1812 prevented the project from being carried out.'[5]

'You must first of all speak to the eyes.' Abel Gance liked to quote the Emperor's phrase. An expert in matters of *propaganda fide*, Napoleon knew immediately that he was dealing with a perfectly staggering *new generation of media*.

When you stare at the Gorgon, the sparkle in her eye dispossesses you, makes you lose your own sight, condemns you to immobility.[6] With the panorama and the diorama's play of colour and lighting, both fated to vanish at the beginning of the twentieth century only to be replaced by photography, the Medusa Syndrome comes into its own. We are not interested here in Daguerre the scenery-painter, doing sets for the Paris Opera or the Ambigu Comique, but Daguerre the lighting engineer, the master technician, whose application of the image to an architectural construct used absolutely realistic and totally illusory time and movement. In his *Description of the Techniques of Diorama Painting and Lighting*, Daguerre writes: 'Only two effects were actually painted on – day on the front of the canvas, night on the back, and one could only shift from one to the other by means of a series of complicated combinations of media the light had to pass through. But these produced an infinite number of additional effects similar to those Nature offers in its course from morning to night and vice versa.'

Elsewhere, Benezit writes: 'Daguerre made constant use of the dark room in his studies of lighting and the *living image...* which took shape on the screen drove him wild with excitement. Here was his dream come true; it now only remained to fix it.'

Nièpce had fixed his first negatives in 1818. Daguerre wrote to him for the first time in 1826. In 1829, Nièpce became interested in the diorama and joined forces with Daguerre. In 1839 Daguerre was practically wiped out but this did not stop the daguerreotype from being unveiled solemnly that same year before the public of Paris.

The perception of appearances determinedly stopped having anything to do with some kind of spiritual approach (in Leibniz's sense, if you like, accepting the existence of mind as a substantial reality). The artist now had a double, a being led astray by representational techniques and their reproductive power, not to mention the circumstances surrounding their occurrence, they very phenomenology.

As we have seen, the multi-dimensional approach to reality of investigative techniques has had a decisive influence on the instrumentalisation of the public image (propaganda, advertising, etc) as well as on the birth of modern art and the emergence of the documen-

tary. The adjective *documentary* (having the character of a document) was actually admitted by Littré in 1879, the same year as the term *impressionism*.

'To see without being seen' is one of the adages of police incommunicability. Well before anthropologists or sociologists came along, the eye the investigator cast over society was eminently external to it. As Commissioner Fred Prase said in a recent interview: 'You wind up living in a world that no longer has any connection with the normal world and when you want to talk about what you're going through, no one knows what you are talking about.' It is only natural that the colonial model and its methods have had a bit input on the means and kinds of scientific and technical analyses adopted by the metropolitan police. It was, for example, a British civil servant. Sir William Hershel, who decreed that all papers pertaining to indigenous people be signed with their thumb prints from 1858. Some thirty years later, Sir Edward Henry devised a fingerprint-classification system which was adopted by the British government in 1897.

The use of fingerprints as identification marks was already well-established in the Far East; the Japanese, among others, had been using fingerprints as signatures from the beginning of the eighth century.

In Europe fingerprints were to be employed in quite a different way. Photographic printing and its possibilities here assuming their full significance, the print would come to be perceived as a *latent image*. Fingerprints, followed by skin prints (pore printing), of any individual alive or dead, would come to be viewed as immutable, realities.

'One fingerprint taken at the scene of the crime is worth even more than the criminal's confession', writes legal officer Goddefroy in his *Manuel de police technique*.[7] The celebrated Alphonse Bertillon, who had invented a system of criminal anthropometry-anthropology, finally succeeded on 24 October 1902, the first person to do so in the history of the police, in identifying a criminal by his fingerprints, photographed and enlarged to more than four times normal size, as he was keen to point out in his report.

The introduction of fingerprints as proof of criminal law marks the decline of the story, of the eye-witness account and the descriptive model, once the basis of every investigation and crucial to writers of previous centuries.

Bertillon also, in a well-known phrase, denounced the deficiency of the human eye and the aberrations of subjectivity: *You only see what you look at and you only look at what you want to see.* The former chief of the Criminal Records Office thereby sums up in his own words the demonstration offered by Poe's Dupin in *The Purloined Letter*, that letter no one can see for looking, like 'the over-largely lettered signs and placards of the street [which] escape observation by

dint of being excessively obvious'. No one can see Poe's letter because everyone is already convinced it must be hidden.

They say you only ask yourself a question when you already know the answer. Dupin, as objective a witness as any camera, is not subject to this ordinary human failing, a failing which makes the scene of the crime almost invisible for the average person who is distracted trying to take note of a welter of details. Metric photographs of the spot, by contrast, record all its particularities regardless, right down to the most insignificant, or which would seem to be so at the time to the eye-witness, whereas, in retrospect, in the course of the investigation, they may turn out to be vital.

The police viewpoint shows just how worthless the story of the person *who was there* is. In spite of the usefulness of witnesses and the elaborate reports of inspectors, the *human eye no longer gives signs of recognition*, it no longer organises the search for truth, it no longer presides over the construction of truth's image, in this mad rush to identify individuals whom the police do not know and have never seen.

The outward manifestation of a thought, its symptom in the literal sense of *sumptôma* (coincidence), is once again to be rejected as far as possible. It is no longer in synch, no longer integrated into the time of the investigation. What counts is what is already there, remaining in a state of *latent immediacy* in the huge junk heap of stuff of memory, waiting to reappear, inexorably, when the time comes.

Empirically acknowledged as tragic, the photographic print was really just that when, at the turn of the century, it became the instrument of the three great authorities over life and death (the law, the army, medicine). This is when it demonstrated its power to reveal the unfolding of a destiny from the word go. As deus ex machina, it was to become just as ruthless for the criminal, the soldier or the invalid, the conjunction between the immediate and the fatal only becoming more solid, inevitably, with the technical progress of representation.

In 1967 the examining judge Philippe Chausserie Laprée presented a three-minute film re-enactment of the murder of a Normandy farmer to the jury of the Court of Assizes in Caen. Laprée, who describes himself as 'an investigation fiend', turns the cases he hears into veritable synopses: using school exercise books, he pastes photographs on the left-hand side and records of cross-examinations in the form of dialogue on the right. Within his video re-enactment he introduced, for the first time in France, a 'legal documentary' in addition to the usual photos of victims and scenes of crimes. Note that he used two ex-army film-makers as assistants on the film rather than his own staff.

Allowed soon after this by the Code of Criminal Law Procedure, video proof would be used to convict criminals on the basis of documents supplied by cameras installed in banks, shops, at traffic lights

and so on. After video refereeing was introduced into sports stadiums, the Belgian officers in charge of the investigation into the Heysel tragedy would have to sit through sixty hours of non-stop video to be able to identify the perpetrators of the violence with any degree of certainty.

In France, lagging well behind England and Germany, law courts such as the district court of Créteil – which has a central projection room and scientific police laboratory fully equipped with video-imaging machines (the ultrasound machine used in medicine for taking ectographs or ecocardiographs) have little by little taken on the trappings of television studios.

In 1988 the police department even decided to deploy *crime-scene technicians*, who are public servants trained to pick up the clues using ultramodern scientific equipment.

What we are witnessing here is the birth of hyper-realism in legal and police representation. As one technician put it: 'Now, with ultrasound, we can bring up the image of a person who's just a tiny speck the size of a pinhead on a video tape, even if they're at the back of a dark room.' Eyewitness accounts having been devalued, it is now possible to do away with their body too, for we now have something more than their image: we have their real-time telepresence.

Instituted in Great Britain and Canada, the telepresence of witnesses who are either in poor health, in danger or too young to appear, poses the whole question of *habeas corpus* all over again. Where the body of the person in custody is still produced before the court (that is, if they agree), they are encircled by electronic microscopes, mass spectrometers and laser videographs in an implacable electronic circuit. Now that the court arena has become first a movie-projection room, then a video chamber, legal representatives of all stripes have lost any hope of creating within it, with the means at their disposal, a *reality-effect* capable of captivating the jury and audience for whom video recorders, networking systems like Minitel, television and sundry computers have become a virtually exclusive way of gathering information, communicating and understanding reality and moving about in it.

How can we hope to pull off the old scenic effects, the *coups de théâtre* that were the pride and joy of our former ring masters? How can we hope to scandalise, surprise, move to tears under the gaze of electronic magistrates that can fast forward or reverse in time and space at will, before a judicial system that is now no more than the distant technological outcome of that merciless *more light* of revolutionary terror, which is, in fact, its very perfection?

Notes

1. Quoted by Walter Benjamin in *L'Homme, le langage et la culture* (Paris: Denoël/Gonthier).
2. Klaus Berger, *Géricault et son œuvre* (Paris: Flammarion, 1968).
3. A certain 'naturalist' school of painting and engraving committed to portraying life's cruelties existed for a long time in Europe, along with an opposing school of drawing and engraving that had scientific pretensions. The latter produced informative anatomical plates for professionals like surgeons and doctors, but also painters and sculptors. Just before the French Revolution, the two genres tended to become indistinguishable. The painter-anatomist Jacques d'Agoty, for instance, oscillated from one to the other in his search for 'the invisible truth of the body'. In his work the engraver's tempered-steel burin alternates with the medical assistant's scalpel. See Jacques-Louis Binet, 'La couleur anatomique', *Traverses*, 14/15, 1979.
4. Léon Rosenthal, *Géricault* (Paris: Collection 'Les Maîtres de l'art', 1905).
5. Germain Bapst, quoted in J. and M. André, 'Une saison Lumière à Montpellier', *Cahiers de la cinémathèque*, 1987.
6. J.-P. Vernant, *La Mort dans les yeux*.
7. E. Goddefroy, *Manuel de police technique*, with a preface by Dr Locard (Paris: Ferdinand Larcier, éditeur, 1931).

Chapter 4

Candid Camera

At the *Second International Video Festival* in Montbéliard in 1984, the Grand Prix went to a German film by Michael Klier called *Der Riese* (The Giant). This was a simple montage of images recorded by automatic surveillance cameras in major German cities (airports, roads, supermarkets. ...). Klier asserts that the surveillance video represents 'the end and the recapitulation' of his art. Whereas in the news report the photographer (cameraman) remained the sole witness implicated in the business of documentation, here no one at all is implicated and the only danger from now on is that the eye of the camera may get smashed by the odd thug or terrorist.

This solemn farewell to the man behind the camera, the complete evaporation of visual subjectivity into an ambient technical effect, a sort of permanent pancinema which, unbeknown to us, turns our most ordinary acts into movie action, into new visual material, undaunted, undifferentiated vision-fodder, is not so much, as we have seen, the *end of an art* – whether it be Klier's or 70s' video art, television's illegitimate offspring. It is the absolute culmination of the inexorable march of progress of representational technologies, of their military, scientific and investigative instrumentalisation over the centuries. With the interception of sight by the sighting device, a mechanism emerges that no longer has to do with simulation (as in the traditional arts) but with substitution. This will become the ultimate special effects of cinematic illusion.

In 1917, when the United States entered the war against Germany, the American review *Camera Work*[1] ceased publication with a final issue on Paul Strand. This involved trotting out yet again the contrived polemic against 'the absolute objective incompetence of photography as inspired by painting, the confusion perpetuated between the photograph and the painted picture by the use of lighting, emul-

sions, retouching and various other tricks of process, all consequences of the eccentric relations kept up between the two modes of representation, the absolute necessity of *rejecting pictorialism as an avant-garde process.*'[2]

In reality the debate derived especially from the fact that, like most technical inventions, photography delivers a hybrid. Thanks to Nicéphore Nièpce's correspondence, we can trace the hybridisation process relatively easily. To start with, there was the substantial art heritage (such as the use of the camera obscura, tonal values and the negative as in etching and engraving). The recent invention of lithography then gave Nièpce the idea of selective permeability in the image base when exposed to a fluid. ... Then, of course, there was the industrial application of lithography and the power of the lithograph to be mechanically reproduced. Science also came into it ultimately, since Nièpce was using the same instruments as Galileo, the lens of the microscope or refracting telescope. The pictorialists were interested in the first of these three applications and there is not a lot of difference between Nièpce's photographic work and theirs. It is this dependence that Strand, in the middle of the war, hoped to erode by insisting that the photograph was first and foremost an objective document, hard evidence.

That same year, under General Patrick's orders, Edward Steichen took over the direction of the American Expeditionary Force's aerial photographic operations in France. Approaching forty, with a background as a painter-photographer, Steichen was one of the masters of pictorialism. He was also a true francophile, and had visited France numerous times from 1900 onwards to meet Rodin, Monet and a few of the other greats.

With a force of fifty-five officers and 1,111 enlisted men, Steichen was to organise aerial-intelligence image production 'like a factory', thanks to the division of labour (the Ford car assembly lines were already in operation in 1914!). Aerial observation had in fact stopped being episodic from the beginning of the war; it was not a matter of images now, but of an uninterrupted stream of images, millions of negatives madly trying to embrace on a daily basis the statistical trends of the first great military-industrial conflict. Initially neglected by the military hierarchy, after the Battle of the Marne the aerial photograph was also to come to lay claim to a scientific objectivity comparable to that of medical or police photography. As a professional effort it was already nothing more than the interpretation of signs, the development of visual codes prefiguring contemporary systems of digital-image restoration. The secret of victory – *predictive capability* – would henceforth reside in high-powered performance in reading and deciphering negatives and films.

Vaguely lumped in the same category as spies, civilian film-makers and photographers were generally kept out of military zones. The job

of presenting the war in a personal way to those left behind was, essentially, left to painter-photographers, illustrators and engravers working on newspapers, almanacs and illustrated magazines. These were flooded with fictional documents, cleverly touched-up photos, more or less authentic tales of dazzling individual acts and heroic battles from a bygone era.

When the war was over, Steichen holed himself up in his house in the French countryside, utterly depressed. There he burned all his previous work, swearing never to touch a brush again, to forsake everything that smacked of pictorialism *for the redefinition of the image as directly inspired by instrumental photography and its scientific processes.* With Steichen and a few other survivors of the Great War, the war shot became that of the American Dream; its images soon merged with the equally disidentified images of the great industrial sales-promotion system and its codes in the launching of mass consumerism, of proto-pop culture ... President Roosevelt's declaration of 'peace of the world'.

But Steichen claimed to have only been able to carry out his military mission properly thanks to his knowledge of French art (the Impressionists, the Cubists and especially the work of Rodin). There is nothing paradoxical about this statement. As Guillaume Apollinaire wrote on the subject of Cubism in about 1913, *the main aim of the new art is to register the waning of reality*: an aesthetic of disappearance had arisen from the unprecedented limits imposed on subjective vision by the instrumental splitting of modes of perception and representation.[3]

At the end of the Great War, the cannons may well have stopped smoking, but the intense phonic and optical activity continued unabated. The *steel storms* of a war which, according to Ernst Jünger, *hoed into places more than people*, were succeeded by a media conflagration that continued to spread, regardless of fragile peace treaties and provisional armistices. Immediately after the war Britain decided to abandon classic armaments somewhat and to invest in the logistics of perception: in propaganda films, as well as observation, detection and transmission equipment.

The Americans prepared future operations in the Pacific by sending in film-makers who were supposed to look as though they were on a location-finding mission, taking aerial views for future film productions. John Ford was one. From on board a freighter, Ford meticulously filmed the approaches and defences of all the major Eastern ports. Not surprising, Ford found himself appointed as head of the OSS (Office of Strategic Services) some years later. He took practically the same risks as servicemen in order to film the Pacific War (losing an eye in the Battle of Midway in 1942). Among other things,

what Ford would retain of his military career were those almost anthropomorphic camera movements that anticipated the optical scanning of video surveillance.

On their side, defeated, ruined and temporarily disarmed, the Germans had no intentions of giving up. Not yet having the famous Luftwaffe, and no longer having fighter planes, they used light touring planes for observation. Colonel Rowehl recounts: 'We took advantage of a break in the clouds or else we just took pot luck that the French or the Czechs wouldn't pick us up; sometimes we trailed an ad for chocolate behind us!' Month after month, without being disturbed in the slightest, they recorded the progress of the defence of the somber Polish Corridor and, a little while later, of the construction sites along the Maginot Line. While the heavy cement-and-steel infrastructures, roads and railway lines of the next decade's battlefield were being laid, as in a negative, the tinny film-makers' planes committed them to memory in anticipation of the war to come.

One of the first results of this continuation of the First World War through other means – military means of a truly scenic kind – was the invasion of the picture show by the accidental images of the newsreel.

Already at the beginning of the century, particularly in the United States, scraps of newsfilm lying about the cutting-room floor were no longer systematically swept up, 'lost scenes ' to be automatically incorporated into any old bit of junk that could be salvaged by the garbage collection or, at best, the cosmetics industry. These began to be seen as 'viewing matter', recyclable within the film industry itself. Once that happened, *background reality* resurfaced, with blazing fires, storms, cataclysms, assassination attempts, crowd scenes ... but, above all, a mountain of material of military origin. These authentic documents, often judged at the time to be of no immediate interest, suddenly cropped up in the middle of feature films. Such subliminal sequences were inserted wherever editing would allow. These were bombings and magnificent shipwrecks, but also photos of combatants, unknown soldiers transformed into chance extras whose ultimate talent was to reveal to astute members of the audience how impoverished the performances and special effects of the period piece really were; as though military or other facts gave themselves up more generously to the sleepwalker's eyes of automatic cameras, or to the curiosity of unskilled photographers, than to the masterly contrivances of the top pros, the elite of career film-makers.

Soon after the Second World War, by a curious reversal, I found I just could not wait for these casual shots to appear on the screen, with all their incomparable emotional impact, whereas scenes played by the stars of the moment seemed like 'time out' to me, boring. I will never forget, either, when Frank Capra's famous *Why We Fight* series was screened in the main auditorium of the *Gaumont Palace Theatre* and seeing, for the first time, colour sequences of movie-camera ma-

chine guns in which that old *kinêmaatos* magic appeared in all its primitive simplicity.

While busy shooting *Napoléon* (1925–7), Abel Gance scribbled in his notebook: 'Reality leaves a lot to be desired . . . ', whereas the film critic André Bazin, going through montages of old newsreels, is glad he never became a film-maker. Reality, he reckons, will outdo any mere director every time and with inimitable flair, too. In fact, the ever-increasing use of scraps already posed a problem for the future of the picture show which was not, as Méliès had supposed, the 'seventh art', but rather an art that took something from all the other arts – architecture, music, the novel, theatre, painting, poetry, etc. In other words, all former modes of perception, reflection and representation. Like them, therefore, and despite its apparent novelty, it found itself subject to a swift, ineluctable ageing process. What happened to cinema was no different from what had happened to painting and the traditional arts when the Futurists and Dada burst on the scene at the beginning of the century. Jean Cocteau understood this only too well. In 1960, just before his death he declared: 'I'm giving up making films since technological progress means anyone can do it.'

That is exactly what it is all about. In popularising a futurist vision of the world, the cinematic features of the man of war, following on those of the documentary school, encouraged cinemagoers more and more to reject all former registers: actors, scriptwriters, directors and designers either had to get out of the way of their own accord or agree to be mown down by the camera's so-called objectivity.

Once a photographer in French aerial reconnaissance and perfectly accustomed to accidental vision, the director Jean Renoir made his actors rehearse for hours on end till they had learned to forget all conventional references. 'Do it as if you've never seen it done, as if you've never done it before, the way in real life, in reality, one does everything for the first time!'

Rossellini would go one step further, incorporating the casual war shot into the script and into the shoot itself. *Roma, Città Aperta* was made with a simple documentary film-making permit, not easy to get from the allied military authorities. 'The entire film was a re-enactment of a news film', wrote Georges Sadoul, and that is precisely why it was such a huge hit.

Stroheim had already said: 'Capture, don't reconstruct'. Rossellini was to apply the radical theories of the old *art vivant* to film. He was against composition in editing with its *pathetic little aesthetic jots*, for: *nothing is more dangerous than the aesthetic, than art's dead truths that have had their day and no longer have anything to do with reality The film-maker must gather as many facts as possible in order to create a total image: he must film cold so that everyone is equal before the image.*[4]

None of this was new, and Italian Neo-realism can only be con-

sidered an avant-garde phenomenon to the extent that it operated in the murkiest area of the documentary: that of *propaganda fide*, war propaganda, a transit zone between virtuality and some kind of reality, between potential and action. Here the cinematic is no longer content to give the viewers the illusion that some kind of movement is being performed in front of them; it gets them interested in the forces behind its production, in their intensiveness. Reverting to its (technical, scientific) essence, under cover of objectivity, it turns its back on an art based on simulation and breaks with an aesthetics of sensitive perception that still depended, in the picture show, on the degree, nature and importance of the cinemagoer's past aesthetic experiences, memory and imagination.

Let's not forget that Rossellini had made numerous films for Mussolini and that after the Allied victory he still wrote scripts, more or less secretly, for propaganda films, notably on behalf of Canada, which was then on the brink of civil war.

Eighty years after Rodin's plea in support of arts that were in the process of disappearing, it was cinema's turn to require witnesses, and not merely ocular but existential witnesses at that, cinemagoers becoming an increasingly rare and sceptical breed.

For many film-makers the aim therefore became to create a convincing world and thus accentuate the instantaneity-effect in the spectator, the illusion of being there and seeing it happen.

Eric Rohmer said: 'With cinema, observation does not mean Balzac taking notes; it is not beforehand, *it is here and now.*'

A specialist in criminal law, the American documentary film-maker Fred Wiseman, whose films are no longer financed and distributed by state television, *claims he makes films so he can observe because new technology allows him to do so.* As for editing, he says it makes him feel like he is *sitting in a plane.*

On the other side of the camera, however, all this visual gadgetry only amounts to telesurveillance for Nastassja Kinski, spying on her every transformation as an actress, second by second: 'I sometimes wonder if films are not more of a poison than a tonic, in the end. If these little flashes of light in the night are really worth all the pain. When I cannot get that moment of truth where you feel yourself opening up like a flower, I absolutely loathe the bloody camera. I can just feel this black hole eyeing me, sucking me in, and I feel like smashing it to smithereens.'[5]

For Edward Steichen, in the most banal way possible, the First World War resolved the question posed by Paul Strand in *Camera Work* concerning 'the avant-garde' in photography. The image is no longer solitary (subjective, elitist, artisanal); it is solidary (objective, democratic, industrial). There is no longer a unique image as in art, but the

manufacture of countless prints, a vast panoply of imagery synthetically reproducing the natural restlessness of the spectator's eye. *Camera Work* only ran to a thousand copies, with only a dozen full-page photographic reproductions, stuck in by hand, in each issue, whereas Steichen kept about 1,300,000 military prints which wound up in his personal collection after the war. Futhermore a large number of these photographs were exhibited and sold as products of Steichen's authorship and as his property, that exotic art estate which war photographers, paradoxically, maintain to this day. This applies to photographers in Hitler's PK or the *British Army Film and Photographic Unit*, as well as the big modern agencies. Steichen also ended up as Director of the Photography Department of the Museum of Modern Art in New York, this last appointment simply translating a persistent ambiguity in reading and interpreting the photographic document.

In January 1940 the British Ministry of Information, formed in September 1939, published a memorandum reviewing the position of the official army photographic units. This memorandum actually amounted to a long-awaited revolution, putting an end to press use of military photographs that were seen to be too lifeless, too technical and therefore ineffectual for a population called on to furnish an unprecedented war effort. Clearly it was a question of knowing how to reach and mobilise the millions of people who had become habitués of the picture houses (most people went to the pictures on average once a week), the readers of the big illustrated magazines, ordinary, everyday visionaries for whom daily life was now no more than a film mix, a reality with endless superimpositions.

At the end of 1940, inspired by Hitler's initiatives of the 30s, the Ministry 'persuaded' picture-theatre managers to include shorts of five to seven minutes in their programmes. These were veritable commercial breaks ahead of their time, and they paved the way for the distribution of documentary pseudo-films. Roger Manvell chuckled at the time in *Film* that while they were being screened 'the audience could change its seats and buy its chocolate'.[6] In any case, the movement had been launched and the public's craving for *cinéma du réel* only became more and more compulsive.

Faced with Hitler proclaiming that *the function of the artillery and infantry will be taken over in the future by propaganda*, John Grierson, that veteran pioneer of a cinema liberated by the *candid camera*, felt moved to write in *Documentary News Letters*, March 1942, that through propaganda: 'We can give [the citizen] a *leadership of the imagination* which our democratic education has so far lacked. We can do it by radio and film and a half a dozen other imaginative media.' But most feature-film directors were already making *semi-documentary films*, thereby achieving the fusion-confusion desired in the first instance by the Ministry of Information.

53

From the outset of the war, a significant British colony had left Hollywood. Actors, scriptwriters, photographers and directors rushed home to serve their country, then under threat of Nazi invasion. Thanks to people like Leslie Howard, the Special Branch (Propaganda) would finally twig that artists who had just won the battle for the New Deal in the United States and raised the morale of a whole nation in the grip of economic depression, had the power, with their particular talents, to do likewise in time of war, stirring the masses to unsuspected heights and finding as yet unguessed shortcuts to victory. Cecil Beaton was among them.[7]

A London gentleman and Hollywood photographer, society portraitist, consummate traveller, most intimate friend of Greta Garbo, *Vogue* contributor, etc., Beaton, like Steichen in 1917, was nearly forty when the Second World War broke out. He was to do the same thing, only the other way round. Where Steichen had abandoned pictorialism and his visits to Rodin twenty years earlier, only to end up in the Hollywood dream factory, Beaton started from a position of extreme Hollywood sophistication only to discover finally in sculptor Henry Moore's portraits of miners his own personal way of photographing a media war that was no longer restricted to the battlefield proper. Its hold now suddenly extended from the physical to the ideological and the psychological.

Beaton's idea was simple: like Moore's miners, committed to daily heroics, men and women at war, from all walks of life, no longer had anything in common psychologically with their peace-time selves. The camera, therefore, ought to be able to capture this difference, this personal transformation which was obvious from the look on people's faces, in their attitudes. A few years earlier, new kinds of film and especially cameras like the Leica, Rolleiflex or Ermanox had become available, offering exposures of well under a second. So Beaton set out armed with his faithful Rollei an a few primitive flashbulbs to conduct what he called his *private war*. This master of appearances travelled to appearance's outer reaches to catch there, off-guard, with only the bare essentials, technically speaking, the personal energy of the war's thousands of actors, famous or unknown, in an ultimate and unconscious return to basics for the *living art of photography* as defined some hundred years earlier by Nadar:

'The theory of photography can be taught in an hour, preliminary technical notions in a day. ... What cannot be taught is the moral intelligence of the subject, or the instinctive tact that puts you in touch with the model, allowing you to size them up and to steer them towards their habits, their ideas, according to each person's character. This enables you to offer something more than the ordinary, accidental plastic reproduction that the humblest laboratory assistant could manage. It enables you to achieve the most familiar, the most

positive resemblance: a speaking likeness. This is the psychological side of photography. I don't think that is too ambitious a term.'

From the wounded lying in hospital to munitions workers and the very young pilots of the RAF, aware of their impending doom; from bomb-blasted London to the Libyan desert and Burma, Beaton went all over the various battlefields as official war photographer for the Royal Air Force. But he never showed them. This caused friction with a military propaganda outfit that was somewhat out of date in its brief 'to *establish photographically* the most colossal demonstration of force, to attempt the impossible ... not just photograph one plane but sixty plans at once, not one tank but one hundred!'

Beaton's most original endeavour remained unknown for a long time. He himself would continue to wonder how he managed to take his war pictures. 'My most serious work', he said of them, just before his death in 1980, 'work that made everything I'd done before passé; I've never known what part of me it could possibly have come from.'

Edward Steichen, on the other hand, though over sixty, went off once more to war. In the United States the British Documentary Movement had enjoyed considerable influence from the beginning of the 30s. Paul Strand now headed the famous *New York School*. The former photographer had become a film producer and director in the same intellectual line as Joris Ivens, who would become involved in the amalgamation of reportage, old newsreels and fictional documents like *Why We Fight*, as well as Robert Flaherty and Fred Zinnemann, the young German antifascist émigré.

Steichen was no longer interested in giving the public instrumental photographic shots or, conversely, bad special effects. He, too, was convinced of the need to reveal the human drama of *the just war* as accurately as possible to the American people for whom the Second World War was still just a war of machines, of mass production. Having won over the sceptics, Steichen took shots of everything from armament factories to the great aero-naval units of the Pacific Fleet. Under his command, freshly trained teams of military photographer were essentially detailed to give an account of daily life on board the *Saratoga*, the *Hornet*, the *Yorktown*. ... Steichen had never really had a chance to see men at war in 1917; he now discovered that they were adolescents worn out before their time by the crushing weight of the industrial arsenal, the new giganticism in equipment. Roosevelt died in April 1945, taking the old American Dream with him; Steichen's units took their last photographs in Hiroshima in September. With the nuclear flash (at $1/15,000,000$th of a second), the fate of military photography once more began to look grim. On the eve of the Korean War, significantly, Steichen was appointed Director of the Photography Department of the Museum of Modern Art in New York.

Photographers, the group who had contributed so much to the Allied victory against the Nazis, were soon to be precipitate Ameri-

ca's defeat in Vietnam. The hopes and inner harmony of those who had fought *the just war* had long ceased to light up soldiers' faces from within, but what the *subjective photo* now revealed was truly alarming. John Olsen and his cohorts showed piles of American corpses, soldiers out of their minds on drugs, the mutilation of children and civilians caught up in the terrorism of *the dirty war* (with well-known consequences for American public opinion).

Once the military twigged that photographers, steeped in the traditions of the documentary, now lost wars, image hunters were once again removed from combat zones. This is perfectly apparent with the Falklands war, a war that has no images, as well as in Latin American, Pakistan, Lebanon, etc. Representatives of the press and television, witnesses now suddenly regarded as a pest, are locked up or just plain murdered. According to Robert Ménard, the founder of 'Reporters sans frontières', in the year 1987 around the globe 188 journalists were arrested, 51 expelled, 34 assassinated and 10 kidnapped.

The last big international agencies are in serious trouble, while magazines and newspapers are busy replacing the great photo-essays of the likes of London, Clemenceau, Kipling, Cendrars or Kessel, with a revival of the old media terrorism, a brand of *investigative journalism* still best typified by the Watergate Scandal and the *Washington Post*'s campaign.

Having become the latest form of psychological warfare, terrorism imposes new media skills on its diverse protagonists. The military and secret services extend their control: General Westmoreland can attack 'information run riot' and sue the television channel CBS; in Europe there is the British Government's raid on the *New Statesman* weekly, among other things. Terrorists themselves, in a bout of role reversal, indulge in *a savage documentary genre*, offering the press and television degrading photos of their victims, who are often reporters or photographers, or doing video-location recces for sites that will become the scenes of their future crimes.

In 1987 the experts in charge of the 'Action Directe' file had to wade through more than sixty cassettes seized a the group's hideout in Vitry-sur-Loges. Specifically, they were seeking those bearing on the assassination of Georges Besse, Renault's Managing Director.

Notes

1. *Camera Work*, the celebrated review published in New York by Alfred Stieglitz from 1903 to 1917, circulated the work of pictorialists such as Kühn, Coburn, Steichen and Demachy.
2. See Allan Sekula, 'Steichen at war', *Art Forum*, December 1975, and also Christopher Phillips, *Steichen at War* (New York: Harry N. Abrams, 1981).
3. We may also wonder what Rodin meant, since he only liked working with destructible, extremely malleable material like clay or plaster; there's a strange similarity between his work and the modelling of the battlefield of the Great War over which reconnaissance planes used to fly, keeping a close eye on the geological metamorphoses of bomb-damaged landscapes.
4. Robert Rossellini, *Fragments d'une autobiographie* (Paris: Ramsay, 1987).
5. *Studio*, 7.
6. Roger Manvell, *Film* (Harmondsworth: Pelican Books, 1977), p. 96.
7. In 1981 the Imperial War Museum in London published a remarkable album, *War Photographs 1939–1945*, featuring 157 of Beaton's photographs previously scattered throughout the press (*The Sketch. Vogue, Illustrated London News, Life*, etc.).

Chapter 5

The Vision Machine

'Now objects perceive me', the painter Paul Klee wrote in his *Notebooks*. This rather startling assertion has recently become objective fact, the truth. After all, aren't they talking about producing a 'vision machine' in the near future, a machine that would be capable not only of recognising the contours of shapes, but also of completely interpreting the visual field, of staging a complex environment close-up or at a distance? Aren't they also talking about the new technology of 'visionics': the possibility of achieving *sightless vision* whereby the video camera would be controlled by a computer? The computer would be responsible for the machine's – rather than the televiewer's – capacity to analyse the ambient environment and automatically interpret the meaning of events. Such technology would be used in industrial production and stock control; in military robotics, too, perhaps.

Now that they are preparing the way for the *automation of perception*, for the innovation of artificial vision, delegating the analysis of objective reality to a machine, it might be appropriate to have another look at the nature of the virtual image. This is the formation of optical imagery with no apparent base, no permanency beyond that of mental or instrumental visual memory. Today it is impossible to talk about the development of the audiovisual without also talking about the development of virtual imagery and its influence on human behaviour, or without pointing to the new *industrialisation of vision*, to the growth of a veritable market in synthetic perception and all the ethical questions this entails. This should be considered not only in relation to control of surveillance, and the attendant persecution mania, but also primarily in relation to the philosophical question of the *splitting of viewpoint*, the sharing of perception of the environment between the animate (the living subject) and the inanimate (the

object, the seeing machine). Questions which introduce, de facto, the question of 'artificial intelligence' since no *expert system*, no fifth-generation computer could come into being without the capability of apprehending the surrounding milieu.

Once we are definitively removed from the realm of direct or indirect observation of synthetic images created *by the machine for the machine*, instrumental virtual images will be for us the equivalent of what a foreigner's mental pictures already represent: an enigma.

Having no graphic or videographic outputs, the automatic-perception prosthesis will function like a kind of mechanized imaginary from which, this time, we would be totally excluded.

This being the case, how can we possibly turn around and reject the *factual* nature of our own mental images since we would have to call on them to be able to guess, to work out roughly what the vision machine was picking up?

This impending mutation of the movie or video-recording camera into a computerised vision machine necessarily brings us back to the debate about the subjective or objective nature of mental imagery.

Increasingly relegated to the realm of idealism or subjectivism – in other words, the irrational – mental images have remained in the dark for quite a while as far as science goes. This has been the case despite the fact that the huge spread of photography and film meant an unprecedented proliferation of new images in competition with the usual array. It was not until the 60s and work on optoelectronics and computer graphics that people began to take a fresh look at the psychology of visual perception, notably in the United States.

In France studies in neurophysiology led to quite a change in the status of mental imagery. J.-P. Changeux, for instance, in a recent work, no longer talks of images but of *mental objects*, going so far as to spell out that it will not be long before these appear on the screen. In two hundred years the philosophical and scientific debate itself has thus similarly shifted from the question of the *objectivity* of mental images to the question of their *reality*. The problem, therefore, no longer has much to do with the mental images of consciousness alone. It is now essentially concerned with the instrumental virtual images of science and their paradoxical facticity.

To my mind, this is one of the most crucial aspects of the development of the new technologies of digital imagery and of the synthetic vision offered by electron optics: the relative fusion/confusion of the factual (or operational, if you prefer) and the virtual; the ascendancy of the 'reality effect' over a reality principle already largely contested elsewhere, particularly in physics.

How can we have failed to grasp that the discovery of retinal retention that made the development of Marey's chronophotography and the cinematography of the Lumière brothers possible, also pro-

pelled us into the totally different province of the mental retention of images?

How can we accept the factual nature of the frame and reject the objective reality of the cinemagoer's virtual image, that visual retention which is not produced solely by the retina, as we once thought, but by the way our nervous system records ocular perceptions? More to the point, how can we accept the principle of retinal retention without also having to accept the role of memorisation in immediate perception?

The moment high-speed photography was invented, making cinema a concrete possibility, the problem of the paradoxically real nature of 'virtual' imagery was in fact posed.

Any *take* (mental or instrumental) being simultaneously a *time take*, however minute, *exposure time* necessarily involves some degree of memorisation (conscious or not) according to the speed of exposure. Hence the familiar possibility of subliminal effects once film is projected at over 60 frames a second.

The problem of the objectivisation of the image thus largely stops presenting itself in terms of some kind of paper or celluloid *support surface* – that is, in relation to a material reference space. It now emerges in relation to time, *to the exposure time that allows or edits seeing*.

So the act of seeing is an act that proceeds action, a kind of pre-action partly explained by Searle's studies of 'intentionality'. If seeing is in fact foreseeing, no wonder forecasting has recently become an industry in its own right, with the rapid rise of professional simulation and company projections, and ultimately, hypothetically, the advent of 'vision machines' designed to see and foresee in our place. These synthetic-perception machines will be capable of replacing us in certain domains, in certain ultra high-speed operations for which our own visual capacities are inadequate, not because of our ocular system's limited depth of focus, as was the case with the telescope and the microscope, but because of the limited *depth of time* of our physiological 'take'.

Physicists normally distinguish two main categories of energetics: potential (static) energy, and kinetic energy, which causes movement. Perhaps we might now need to add a third category: *kinematic energy*, energy resulting from the effect of movement, and its varying speed, on ocular, optical or optoelectronic perception.

Let's not forget, either, that there is no such thing as 'fixed sight', or that the physiology of sight depends on the eye's movements, which are simultaneously incessant and unconscious (motility) and constant and conscious (mobility). Or that the most instinctive, least-controlled glance is first a sort of circling of the property, a complete scanning of the visual field that ends in the eye's choice of an object.

As Rudolf Arnheim understood, sight comes from a long way off. It is a kind of dolly in, a perceptual activity that starts in the past in order to illuminate the present, to *focus on* the object of our immediate perception.

The space of sight is accordingly not Newton's space, absolute space, but Minkovskian event-space, relative space. And it is not only the dim brightness of these stars that comes to us from out of the distant past, out of the mists of time. The weak light that allows us to apprehend the real, to see and understand our present environment, itself comes from a distant visual memory without which there would be no act of looking.

After *synthetic images*, products of info-graphic software, after the digital image processing of computer-aided design, we are on the verge of *synthetic vision*, the automation of perception. What will be the effects, the theoretical and practical consequences for our own 'vision of the world' of Paul Klee's intuition's becoming reality? This doubling of the point of view cannot be compared to the proliferation of surveillance cameras in public places over a dozen or more years. Although we know that the imagery from video cameras in banks and supermarkets is relayed to a central control-room, although we can guess the presence of security officers, eyes glued to control monitors, with *computer-aided perceptions* – visionics – it is actually impossible to imagine the pattern, to guess the interpretation produced by this sightless vision.

Unless you are Lewis Carroll, it is hard to imagine the viewpoint of a doorknob or a button on a cardigan. Unless you are Paul Klee, it is not easy to imagine artificial contemplation, the wide-awake dream of a population of objects all busy staring at you.

Behind the wall, I cannot see the poster; in front of the wall, the poster forces itself on me, its image perceives me.

This inversion of perception, which is what advertising photography suggests, is now pervasive, extending from roadside hoardings to newspapers and magazines. Not a single representation of the kind avoids the 'suggestiveness' which is advertising's raison d'être.

The graphic or photographic quality of the advertising image, its *high definition* as they say, is no longer a guarantee of some kind of aesthetic of precision, of photographic sharpness etc. It is merely the search for a stereoscopic effect, for a third dimension. This then in itself becomes what the message projects, a commercial message of some kind that strives, through our gaze, to attain the depth, the density of meaning it sadly lacks. So let's not entertain any further illusions about photography's commercial prowess. The phatic image that grabs our attention and forces us to look is no longer a powerful image; it is a cliché attempting, in the manner of the cineframe, to

inscribe itself in some unfolding of time in which the optic and the kinematic are indistinguishable.

Being superficial, the advertising photo, in its very resolution, participates in the decadence of the *full* and the *actual*, in a world of transparency and virtuality where representation gradually yields to genuine *public presentation*. Inert despite a few antiquated gimmicks, the advertising photograph no longer advertises anything much apart from its own decline in the face of what the real-time telepresence of objects can do, as home shopping and banking already make clear. Surely we have all seen trucks plastered with ads filing past in close formation like so many ambulatory commercial breaks, putting a derisory finishing touch to the usual audiovisual fix on TV.

Guaranteed to have public use-value due to the poor definition of the video image, and still able to impress readers and passers-by, the publicity shot will probably see this advantage diminish with high-definition television, the opening of a window whose cathodic transparency will soon replace the transparency effect of the classic display window. Far be it from me to deny photography an aesthetic value. It is just that there is also a logic, a logistics of the image, and it has evolved through different periods of propagation, as we know.

The age of the image's *formal logic* was the age of painting, engraving and etching, architecture; it ended with the eighteenth century.

The age of *dialectic logic* is the age of photography and film or, if you like, the frame of the nineteenth century. The age of *paradoxical logic* begins with the invention of video recording, holography and computer graphics ... as though, at the close of the twentieth century, the end of modernity were itself marked by the end of a logic of public representation.

Now, although we may be comfortable with the *reality* of the formal logic of traditional pictorial representation and, to a lesser degree, the *actuality* of the dialectical logic governing photographic and cinematic representation,[1] we still cannot seem to get a grip on the *virtualities* of the paradoxical logic of the videogram, the hologram or digital imagery.

This probably explains the frantic 'interpretosis' that still surrounds these technologies today in the press, as well as the proliferation and instant obsolescence of different computer and audiovisual equipment.

Lastly, *paradoxical logic* emerges when the real-time image dominates the thing represented, real time subsequently prevailing over real space, virtuality dominating actuality and turning the very concept of reality on its head. Whence the crisis in traditional forms of public representation (graphics, photography, cinema ...), to the great advantage of presentation, of a *paradoxical presence*, the long-distance telepresence of the object or being which provides their very existence, here and now.

This is, ultimately, what 'high definition' or high resolution means; and it no longer applies to the (photographic, television) image, but to reality itself.

With paradoxical logic, what gets decisively *resolved* is the reality of the object's *real-time* presence. In the previous age of dialectical logic, it was only the delayed-time presence, the presence of the past, that lastingly impressed plate and film. The paradoxical image thus acquires a status something like that of surprise, or more precisely, of an 'accidental transfer'.

There is a correspondence here between the reality of the image of the object, captured by the lens of the pick-up camera, and the virtuality of its presence, captured by a real-time 'surprise pick-up' (of sound). This not only makes it possible to televise given objects, but also allows tele-interaction, remote control and computerised shopping.

But getting back to photography, if advertising's photographic cliché begins the process whereby the phatic image radically reverses the dependent perceiver-perceived relationship, thereby beautifully illustrating Paul Klee's phrase *now objects perceive me*, this is because it is already more than a brief memorandum, more than the photographic memento of a more or less distant past. It is in fact *will*, the will to engage the future, yet again, and not just represent the past. The photogram, furthermore, had already begun to manifest such a will at the end of the last century, well before the videogram finally pulled it off.

So, to an even greater extent that the documentary shot, the publicity shot foreshadows the phatic image of the audiovisual.[2] This public image has today replaced former public spaces in which social communication took place. Avenues and public venues from now on are eclipsed by the screen, by electronic displays, in a preview of the 'vision machines' just around the corner. The latter will be capable of seeing and perceiving in our place.

Remember we have already witnessed the recent appearance of the Motivac, a new device for measuring TV audiences which is a sort of black box built into the set. The Motivac is no longer happy just to indicate when the set is turned on, as its predecessors were; it indicates the actual presence of people in front of the screen. ... This makes for a fairly basic vision machine, certainly, but one which clearly points the way in mediametric monitoring, especially when you remember how zapping has devastated the audience of commercials.

Really, once *public space* yields to *public image*, surveillance and street lighting can be expected to shift too, from the street to the *domestic display terminal*. Since this is a substitute for the City terminal, the private sphere thus continues to lose its relative autonomy.

The recent installation of TV sets in prisoners' cells rather than just

recreation rooms ought to have alerted us. Not enough has been said about this decision even though it represents a typical mutation in the evolution of attitudes regarding incarceration. Since Bentham, goal has normally been identified with the panoptic, in other words, with a central surveillance system in which prisoners find themselves continually under someone's eye, within the warder's field of vision.

From now on, inmates can *monitor actuality*, can observe televised events – unless we turn this around and point out that, as soon as viewers switch on their sets, it is they, prisoners or otherwise, who are in the field of television, a field in which they are obviously powerless to intervene. ...

'Surveillance and punishment' go hand in hand, Michel Foucault once wrote. In this imaginary multiplication of inmates, what other kind of punishment is there if not *envy*, the ultimate punishment of advertising? As one prisoner put it when asked about the changes: 'Television makes being in gaol harder. You see all you're missing out on, everything you can't have.' This new situation not only involves imprisonment in the cathode-ray tube, but also in the firm, in post-industrial urbanisation.

From the town, as theatre of human activity with its church square and market place bustling with so many *present* actors and spectators, to CINECITTA and then TELECITTA, bustling with *absent* televiewers, it was just a short step through that venerable urban invention, *the shopwindow*. This putting behind glass of objects and people, the implementation of a transparency that has intensified over the past few decades, has led, beyond the optics of photography and cinema, to an optoelectronics of the means of television broadcasting. These are now capable of creating not only window-apartments and houses, but window-towns window-nations, media megacities that have the paradoxical power of *bringing individuals together long-distance*, around standardised opinions and behaviour.

'You can get people to swallow anything at all by intensifying the details', Bradbury claimed. In the way voyeurs only latch on to the suggestive details, it is indeed the intensive details, the very intensity of the message, that counts now, rather than any exploration of the scope or space of the public image.

'Unlike cinema', Hitchcock said, 'with television there is no time for *suspense*, you can only have *surprise*'. This is the very definition of the paradoxical logic of the videoframe which privileges the accident, the surprise, over the durable substance of the message. This is already what happened within the dialectical logic of the cineframe, simultaneously valorising as it did the extensiveness of duration and an extension of representational range.

Whence the sudden welter of instantaneous retransmission equipment, in town, in the office, at home: all this real-time TV monitoring tirelessly on the lookout for the unexpected, the impromptu, what-

ever might suddenly crop up, anywhere, any day, at the bank, the supermarket, the sports ground where the video referee has not long taken over from the referee on the field.

This is the industrialisation of prevention, or prediction: a sort of panic anticipation that commits the future and prolongs 'the industrialisation of simulation', a simulation which more often than not involves the probable breakdown of and damage to the systems in question. I'll say it again: this doubling up of monitoring and surveillance clearly indicates the trend in relation to public representation. It is a mutation that not only affects civilian life and crime, but also the military and strategic areas of Defence.

Taking measures against an opponent often means taking countermeasures vis-à-vis the opponent's threats. Unlike defensive measures, unlike visible, ostentatious fortifications, countermeasures involve secrecy, the greatest possible dissimulation. The power of the countermeasure thereby resides in its apparent non-existence.

The chief tack of warfare is accordingly not some more or less ingenious stratagem. In the first instance, it involves the elimination of the *appearance of the facts*, the continuation of what Kipling meant when he said: 'Truth is the first casualty of war'. Here again, it is less a matter of introducing some manœuvre, an original tactic, than of strategically concealing information by a process of disinformation; and this process is less to do with fake effects – once we accept the lie as given – than with the obliteration of the very principle of truth. Moral relativism has always been offensive, from time immemorial, because it has always been involved in the same process. A phenomenon of pure representation, such relativism is always at work in the appearance of events, of things as they happen, precisely because we always have to make a subjective leap in order to recognize the shapes, objects and scenes we are witness to.

This is where the 'strategy of deterrence', involving decoys, electronic and other countermeasures, comes into its own. The truth is no longer masked by eliminated, meaning the truth of the real image, *the image of the real space of the object*, of the missile observed. It is eclipsed by the image televised 'live', or, more precisely, in *real time*.

What is now phoney is not the space of things so much as time, the present time of military objects that, in the end, serve more to threaten than actually to fight.

The three tenses of decisive action, past, present and future, have been surreptitiously replaced by two tenses, *real time* and *delayed time*, the future having disappeared meanwhile in computer programming, and on the other hand, in the corruption of this so-called 'real' time which simultaneously contains both a bit of the *present* and a bit of the *immediate future*. When a missile threatening in 'real time' is

picked up on a radar or video, the present as mediatised by the display console already contains the future of the missile's impending arrival at its target.

The same goes for 'delayed-time' perception, the past of the representation containing a bit of this media present, of this real-time 'telepresence', the 'live' recording preserving, like an echo, the real presence of the event.

The concept of deterrence assumes its proper importance in this context, where the elimination of the truth of the actual war exclusively promotes the terrorising deterrent force of weapons of global destruction.

In fact, deterrence is a major figure in disinformation or, more precisely, according to the English jargon, in *deception*. Most politicians agree this is preferable to the truth of real war, the *virtual* nature of the arms race and the militarisation of science being perceived, despite the economic waste, as 'beneficial', in contrast to the *real* nature of a confrontation that would end in immediate disaster.

But even if common sense agrees that the choice of 'the nuclear non-war' is preferable, who can help but notice that so-called deterrence is not peace, but a relative form of conflict, *a transfer of war from the actual to the virtual*. This is the deception of the war of mass extermination whose means, deployed and endlessly perfected, have been throwing the political economy out of kilter and dragging our societies down into the mire of a general loss of a sense of reality that permeates all aspects of normal life.

It is also incredibly revealing when you think that the atomic bomb, that weapon of deterrence par excellence, itself grew out of theoretical discoveries in a branch of physics that owes everything, or almost everything, to Einstein's Theory of Relativity. Even if Albert Einstein is certainly not guilty of inventing the bomb, as public opinion will have it, he is, on the other hand, among those principally responsible for spreading the notion of relativity. Scrapping the 'absolute' nature of classic notions of space and time was the scientific equivalent, in this case, of *deception* regarding the reality of observed facts.[3]

This crucial turn of events was kept hidden from the public and affects strategy as well as philosophy, economics and the arts.

'Micro-' or 'macro-physical', the contemporary world of the immediate post-war period could no longer count on the reality of the facts, or even of the very existence of some kind of truth. After the demise of revealed truth, scientific truth suddenly bit the dust. Existentialism clearly spelled out the concomitant bewilderment. In the end the *Balance of Terror* is this very uncertainty. The crisis in determinism thus not only affects quantum mechanics, it also affects the political economy, whence all the East-West interpretation fever, that great game of deterrence, with its myriad scenarios starring heads of state in the Pentagon, the Kremlin and wherever else. 'We must put

out excess rather than the fire', Heraclitus wrote. As our protagonists see it, the principle of deterrence reverses these terms, putting out the fire of nuclear war and thereby promoting an exponential growth in scientific and technological excess. And the avowed aim of this excess is endlessly to raise the stakes of confrontation while piously pretending to prevent it, forever to rule it out.

In the face of the discreet devaluation of territorial space which followed from the conquest of circumterrestrial space, geostrategy and geopolitics come on and do their number together as part of the stage show of a regime of perverted temporality, where TRUE and FALSE are no longer relevant. The actual and the virtual have gradually taken their place, to the great detriment of the international economy, as the Wall Street computer crash of 1987, moreover, clearly demonstrated.

Dissimulating the future in the ultra-short time of an on-line 'compunication' (computer communication), *Intensive time* will then replace the *extensive time* in which the future was still laid out in substantial periods of weeks, months, years to come. The age-old duel between arms and armour, offensive and defensive, then becomes irrelevant. Both terms now merge in a new 'high-tech mix', a paradoxical object in which decoys and countermeasures just go on developing, rapidly acquiring a predominantly defensive thrust, the image becoming more effective as ammunition than what it was supposed to represent!

Faced with this fusion of the object with its equivalent image, this confusion between presentation and televised representation, the processes of real-time deception will win out over the weapons systems of classic deterrence. East–West conflict in the way the reality of deterrence itself is interpreted will gradually be transformed with the first fruits of nuclear disarmament.

The traditional opposition between *deterrence* and *self-defence* will then be replaced by an alternative: *deterrence*, based on parading apocalyptic weapons, or *self-defence*, based on this uncertainty about reality, about the very credibility of means implemented. These include the famous American 'Strategic Defense Initiative', or 'Star Wars', whose plausibility is in no way assured.

Remember that there were, at this point, three main classes of weapons: weapons defined either by range or by function, and erratic weapons, the latter prefiguring the decoys and countermeasures mentioned above.

If first-generation nuclear deterrence led to a growing sophistication in weapons systems (enhanced range, precision, miniaturisation of warheads, intelligence ...), this sophistication has itself indirectly led to an increased sophistication in decoys and other countermeasures, which is why rapid target discrimination is so important, not so much now between true and false missiles, as between true

68

and false *radar signatures*, between plausible and implausible images, whether acoustic, optical or thermal

In the age of 'generalised simulation' of military missions (ground, navy or air) we thus land smack bang in the middle of the age of *total dissimulation* – a war of images and sounds, tending to take over from the missile war of the nuclear deterrence arsenal.

The Latin root of the word *secret* means to segregate, to remove from understanding. Today this segregation is no longer a matter of spatial distance but of time-distance. It has become more useful to deceive about duration, to make the image of the trajectory secret, than camouflaging explosives carriers (aircraft, rockets and so on). And so a new ballistics' discipline has emerged: *tracking*.

It is now more vital to trick the enemy about the virtuality of the missile's passage, about the very credibility of its presence, than to confuse them about the reality of its existence. This is where the spontaneous generation STEALTH aircraft come in, those 'discreet' weapons, 'furtive' carriers, virtually invisible to detection

At this juncture we enter a third weapons age, following the prehistoric age of weapons defined by range, and the historic age of 'functional' weapons. With *erratic and random weapons* we move into the post-historic age of the arsenal. ERW are discreet weapons whose functioning depends entirely on the definitive split between real and figurative. Objective lie, unidentified virtual object, they may be classic carriers, made invisible by radar by their smooth aerodynamic shape and special radar-absorbent paint; they may be *kinetic kill vehicles* (KKV), using only speed of impact; or *kinetic-energy weapons*, which are electronic decoys. 'Projective images', ammunition of a new order that dangerously fascinate and deceive the opponent in what is probably a forerunner of the *enhanced radiation weapon*, or neutron bomb, acting at the speed of light itself.

This equipment of deception, this arsenal of dissimulation, has way overshot deterrence. Deterrence can now only take effect by virtue of information, through the disclosure of destructive capabilities, since an unknown weapons system would hardly be in danger of deterring the other player/adversary in a strategic game that calls for announcement, for the advertising of means. Whence the usefulness of military shows and the famous 'spy satellites' that guarantee strategic balance.

'If I were to sum up in one sentence the current stance on smart bombs and saturation attack weapons', W. J. Perry, a former US State Under-Secretary of Defense explained, 'I'd say as soon as you can see a target you can hope to destroy it.'

This statement betrays the new situation as well as partly accounting for the disarmament currently under way. If *what is perceived is*

already finished, what was previously invested exclusively in the deployment of forces must now be invested in dissimulation. So decoy research and development has come to play a leading role in the military-industrial complex, yet one that is itself *discreet*. Censorship regarding 'deception techniques' far exceeds what once surrounded the military secret of the invention of the atomic bomb.

That there has been a reversal in deterrence strategy is obvious. Unlike arms that need to be known to be genuinely dissuasive, 'furtive' weapons can only work if their existence is concealed. This reversal muddies the waters of East–West strategy considerably, since it undermines the very principle of nuclear deterrence in favour of a 'strategic-defense initiative' that no longer rests on the deployment of new arms in space, as President Reagan maintained, but on the uncertainty principle, the unknown quantity in a relative-weapons system whose credibility is no more beyond doubt than its visibility.

This makes the decisive new importance of the 'logistics of perception' clearer, as well as accounting for the secrecy that continues to surround it.[4] It is a war of images and sounds, rather than objects and things, in which winning is simply a matter of not losing sight of the opposition. The will to see all, to know all, at every moment, everywhere, the will to universalised illumination: a scientific permutation on the eye of God which would forever rule out the surprise, the accident, the irruption of the unforeseen.

So, besides the industrial innovation of 'repeating weapons', followed by automatic weapons, we also have the innovation of *repeating images* provided by the photoframe. The video signal then takes over where the radio signal left off, with the videogram in its turn further extending this will to second sight and bringing with it the added possibility of real-time reciprocal telesurveillance – twenty-four hours a day. The last phase of the strategy will finally be ensured by the *vision machine*. The Perceptron, say, will use computer graphics and automatic recognition of shapes (not just contours and silhouettes) – as though the chronology of the invention of cinema were being relived in a mirror, the age of the magic lantern giving way once more to the age of the recording camera, in anticipation of digital holography.

In the face of such representational open slather, the philosophical questions of plausibility and implausibility override those concerning the true and the false. The shift of interest from the thing to its image, and especially from space to time, to the instant, leads to a shift in polarities from the old black-and-white real-figurative dichotomy to the more relative *actual-virtual*.

Unless ... unless what we are seeing is the emergence of a mix, a fusion-confusion of the two terms, the paradoxical occurrence of a unisex reality, beyond good and evil, applying itself this time to the now crucial categories of space and time and their relative dimen-

sions, as a number of discoveries in the areas of quantum indivisibility and superconductivity would already suggest.

If we look at recent developments in 'deception strategy', we find that currently when military staff talk about 'the electronic environment' and the need for a new meteorology in order to ascertain the exact position of countermeasures over enemy territory, they are clearly translating this mutation in the very concept of environment, as well as in the concept of the reality of events occurring within it.

The unpredictability and rapid transformation of atmospheric phenomena become doubly uncertain and ephemeral, but this time in relation to the state of electromagnetic waves, those countermeasures that allow a territory to be defended.

If, as Admiral Gorchkov claims: 'The winner of the next war will be the side who made the most of the electromagnetic spectrum', then we must consider the real environment of military action from now on to be not the tangible, visible, audible environment, but the opto-electronic environment, certain operations already being carried out, according to military jargon, *beyond optical range* thanks to real-time radioelectric pictures.

To grasp this transmutation in the field of action properly we have to refer back to the principle of relative illumination once more. If the categories of space and time have become relative (critical), this is because the stamp of the absolute has shifted from matter to light and especially to light's finite speed. It follows that that which serves to see, to understand, to measure and therefore to conceive reality, is not so much light as its velocity. From now on, speed is less useful in terms of getting around easily than in terms of seeing and conceiving more or less clearly.

The time frequency of light has become a determining factor in the apperception of phenomena, leaving *the spatial frequency of matter* for dead. Whence the unheard of possibility of real-time special effects, decoys that do not so much affect the nature of the object – a missile, say – as the image of its presence, in the infinitesimal instant in which the virtual and the real are one and the same thing for the sensor or the human observer.

Take the *centroidal-effect decoy* for example. The principle here consists, in the first instance, in superimposing on the radar-image that the missile 'sees' an image entirely created by the decoy. This image is more attractive than the real one of the ground target and just as credible for the enemy missile. When this preliminary phase of deception is successful, the missile's homing head locks on to the unit's centre of gravity – 'decoy-image', 'ground target-image'. The deceived missile then only has to be dragged beyond the ship, the entire operation taking no more than a few fractions of a second. As Henri Martre, the head of Aérospatiale, pointed out not long ago: 'Future materials will be conditioned by advances in components and

miniaturisation. It is most likely electronics that will end up destroying a weapon's reliability'.

So after the nuclear disintegration of *the space of matter*, which led to the implementation of a global deterrence strategy, the disintegration of *the time of light* is finally upon us. This will most likely involve a new mutation of the war game, with deception finally defeating deterrence.

Today 'extensive' time, which worked at deepening the wholeness of infinitely great time, has given way to 'intensive' time. This deepens the infinitely small of duration, of microscopic time, the final figure of eternity rediscovered outside the imaginary of the extensive eternity of bygone centuries.[5]

Intensive eternity, in which the instantaneity offered by the latest technologies contains the equivalent of what the infinitely small space of matter contains. The core of time, a temporal atom there in each present instant, an infinitesimal point of perception from where extent and duration are differently conceived, this *relative difference* between them reconstitutes a new real generation, a degenerate reality in which speed prevails over time and space, just as light already prevails over matter, or energy over the inanimate.

If all that appears in light *appears in its speed*, which is a universal constant, if speed is no longer particularly useful, as we once thought, in displacement or transportation, if speed serves primarily *to see*, to conceive the reality of the facts, then duration, like extent, must absolutely be 'brought to light'. All durations, from the most minute to the most astronomical, will then help to expose the intimacy of the image and its object, of space and representations of time. Physics currently proposes to do this by tripling the once-binary concept of the *interval*: on top of the familiar intervals of the 'space' type (negative sign) and the 'tome' type (positive sign), we have the new *interval of the 'light' type* (zero sign). The interface of the live television screen or the computer monitor are perfect examples of this third type of interval.[6]

Since the time-frequency of light has become the determining factor in relative apperception of phenomena and subsequently of the *reality principle*, the vision machine is well and truly an 'absolute-speed machine', further undermining traditional notions of geometric optics like observables and non-observables. Actually, if photo-cinematography is still inscribed in extensive time, promoting expectation and attention by means of *suspense*, real-time video computer graphics is already inscribed in intensive time, promoting the unexpected and a short concentration span by means of *surprise*.

Blindness is thus very much at the heart of the coming 'vision

machine'. The production of *sightless vision* is itself merely the reproduction of an intense blindness that will become the latest and last form of industrialisation: *the industrialisation of the non-gaze.*

Seeing and non-seeing have always enjoyed a relationship of reciprocity, light and dark combining in the *passive* optics of the camera leans. But with the *active* optics of the video computer, notions like toning light down or bringing it up change completely, privileging a more or less marked *intensification of light.* And this amplification is nothing other than the negative or positive change in the velocity of photons – the trace photons leave in the camera as they pass through it being itself linked to the variable speed of the calculations image digitalisation requires, the PERCEPTRON'S computer functioning like a sort of ELECTRONIC OCCIPITAL CORTEX.

Don't forget, though, that 'image' is just an empty word here since the machine's interpretation has nothing to do with normal vision (to put it mildly!). For the computer, the optically active electron image is merely a series of coded impulses whose configuration we cannot begin to imagine since, in this 'automation of perception', *image feedback is no longer assured.* That being, of course, the whole idea.

We should also note, though, that eyesight is itself merely a series of light and nerve impulses that our brain quickly decodes (at 20 milliseconds per image), the question of the 'observation energy' that enables us to observe phenomena remaining unanswered, even now, despite our progress in understanding psychological and physiological blindness.

Speed of light or light of speed? The question remains untouched, despite the above-mentioned possibility of a third form of energy: kinematic energy or *image energy.* This fusion of physical optics and relative kinematics would take its place alongside the two main officially recognised forms of energy – potential and kinetic (active) – thereby throwing light on the controversial scientific term: observed energy.

Observed energy or observation energy? That is still the question, and it is bound to become topical, with the profusion of countless prostheses of computer-enhanced perception of which the Perceptron would be the logical outcome; an outcome of paradoxical logic, though, since 'objective perception' – how machines might perceive things – will be forever beyond us.

Faced with this ultimate in automation, the usual categories of energetic reality are no longer much help. If real time prevails over real space, if the image prevails over the object present, to say nothing of the being, if the virtual prevails over the real, we need to try and analyse the fallout from this logic of 'intensive' time on different physical representations. While the age of 'extensive' time continued to justify dialectic logic *by drawing a clear distinction between potential and real,* the age of intensive time demands a better resolution of

the reality principle, one in which the notion of virtuality would itself come in for a bit of tinkering.

This is why I propose we accept the logical paradox of a veritable 'observation energy' made possible by the Theory of Relativity. The latter sets up the speed of light as a new *absolute* and thereby introduces a third type of interval – light – alongside the classic intervals of space and time. If the path of light is absolute, as its zero sign indicates, this is because the principle of instantaneous emission and reception *change-over* has already superceded the principle of *communication* which still required a certain delay.

Taking into account the third type of energy would therefore help modify the very definition of the real and the figurative, since the question of REALITY would become a matter of the PATH of the light interval, rather than a matter of the OBJECT and space-time intervals.

Surpassing 'objectivity' in this untimely manner, the light-type interval would spawn the *being of the path*, after the being of the subject and the being of the object. As the former would define the appearance or, more precisely, the *trans-appearance* of what is, the question for philosophy would stop being: 'At what space-time *distance* is observed reality?' It would become: 'At what *power*, in other words, at what speed, is the perceived object?'

The third type of interval thereby necessarily adds to the third type of energy: the energy of the kinematic optics of relativity. Accordingly, if the finite speed of light is the absolute that takes over where Newton's now relativised space and time leave off, *the path now steals the jump on the object*. Once this happens, how can we possibly locate the 'real' or the 'figurative' except through some kind of 'clearance' which becomes indistinguishable from an 'illumination' or 'clarification', spatio-temporal spacing being, to the attentive observer, only a particular figure of light, or more precisely still, of the light of speed?

And if speed is not a phenomenon but, indeed, *the relationship between phenomena* (relativity itself), the question raised of the observation distance of phenomena comes down to the question of the power of perception (mental or instrumental). This is why we urgently need to evaluate light signals of perceptual reality in terms of intensity, that is 'speed', rather than in terms of 'light and dark' or reflection or any of the other now outdated shorthand.

When physicists still talk today about *observed energy*, they are definitely misusing the term, and this mistake affects scientific practice itself, since it is speed more than light which allows us to see, to measure and thereby conceive reality.

Some little time ago, the review *Raison présente* asked: 'Has contemporary physics done away with the real?' Done away with it? Not on your life! But it has resolved it, of course – only, in the sense in

which we now speak of better 'image resolution'. Since Einstein, Niels Bohr and company, the temporal and spatial resolution of the real has been being brought off at an endlessly accelerating rate!

At this point we should remember that relativity would not exist without the relative optics (physical optics) of the observer. Einstein was accordingly tempted to call his theory the Theory of Viewpoint in reference to the 'point of view' which necessarily becomes identical with the relative fusion of optics and kinematics, and which is another name for the 'energy of the third kind' which I propose adding to the other two.

In fact if every image (visual, sound) is the manifestation of an energy, of an unrecognised power, the discovery of retinal retention is much more than insight into a *time lag* (the imprint of the image on the retina). It is the discovery of a *freeze-frame effect* which speaks to us of some kind of unscrolling, of Rodin's time that 'does not stand still'; in other words of the intensive time of human perceptiveness. If fixing does occur, at a given moment of sight, this is actually because there exists an energetics of optics, the 'kinematic energetic' finally being merely the manifestation of a third form of power, without which distance and the three-dimensional would not apparently exist, since the said 'distance' could not exist without 'delay', (out)distancing only appearing thanks to the illumination of perception. Much as the ancients, in their own way, understood to be the case.[7]

But by way of conclusion, let us return to the crisis in perceptive faith, to the automation of perception that is threatening our understanding. Apart from video optics, the vision machine will also use digital imaging to facilitate recognition of shapes. Note, though, that the *synthetic image*, as the name implies, is in reality merely a 'statistical image' that can only emerge thanks to rapid calculation of the pixels a computer graphics system can display on a screen. In order to decode each individual pixel, the pixels immediately surrounding it must be analysed. The usual criticism of statistical thought, as generating *rational illusions*, thus necessarily comes down to what we might here call the visual thought of the computer, *digital optics* now being scarcely more than a statistical optics capable of generating a series of visual illusions, 'rational illusions', which affect our understanding as well as reasoning.

In acquiring a *closed-circuit optics*, statistical science – the art of providing information on objective future trends as well as, more recently, an art of persuasion – will probably see its power and power of conviction considerably enhanced, along with its discrimination capacities.

Bringing users a 'subjective' optical interpretation of observed phenomena and not just 'objective' information about proposed

events, the vision machine is in real danger of accentuating the splitting of the reality principle, the synthetic image no longer having anything in common with the statistical inquiry as it is normally conducted. They are already talking about *digital experiments* that will dispense completely with classic 'analytical reflection'. And aren't they also talking about an *artificial reality* involving digital simulation that would oppose the 'natural reality' of classical experience?

'Intoxication is a number', according to Charles Baudelaire. Digital optics is indeed a rational metaphor for intoxication, statistical intoxication, that is: a blurring of perception that affects the real as much as the figurative, as though our society were sinking into the darkness of a voluntary blindness, its will to digital power finally contaminating the horizon of sight as well as knowledge.

As a mode of representation of statistical thought today dominant thanks to data banks, synthetic imagery should soon contribute to the development of this one last mode of reasoning.

Don't forget that the whole idea behind the Perceptron would be to encourage the emergence of fifth-generation 'expert systems', in other words an *artificial intelligence* that could be further enriched only by acquiring organs of perception. ...

Let me end with a fable based on a very real invention this time, the *calculator pen*. It is very straightforward. All you have to do is write the computation on paper, as you would if you were doing the sum yourself. When you finish writing, the little screen built into the pen displays the result. Magic? No way. While you are writing, an optical system *reads* the numbers formed and the electronic component does the sum. So much for the facts. The fable concerns what my pen, a blind pen this time, will write down for you, the reader, as the final words of this book. Imagine for a moment that to write the book I have borrowed technology's state-of-the-art pen: the *reader pen*. What do you think will come up on the screen, abuse or praise? Only, have you ever heard of a writer who writes for his pen... ?

Notes

1. See, for example, the two books by Gilles Deleuze, *L'Image-mouvement* (Paris: Minuit, 1983) and *L'Image-temps* (Paris: Minuit, 1985). Also, more recently, J.-M. Schaeffer, *L'Image précaire* (Paris: Le Seuil, 1988).
2. Phatic image: a technical term employed by Georges Roques in *Magritte et la publicité*.
3. As Céline pointed out: 'For the moment only the facts count, but not for much longer.'

4. Paul Virilio, *Logistique et la perception*, op. cit.
5. On this subject, see Ilya Prigogine and Isabelle Stengers, *Entre le temps et l'éternité* (Paris: Fayard, 1988).
6. Gilles Cohen-Tanudji and Michel Spiro, *La Matière-espace-temps* (Paris: Fayard, 1986), pp. 115–17.
7. See Gérard Simon, *Le Regard, l'être et l'apparance dans l'optique de l'Antiquité* (Paris: Le Seuil, Collection des travaux, 1988).

Index